Watercolour Landscapes

Made Easy

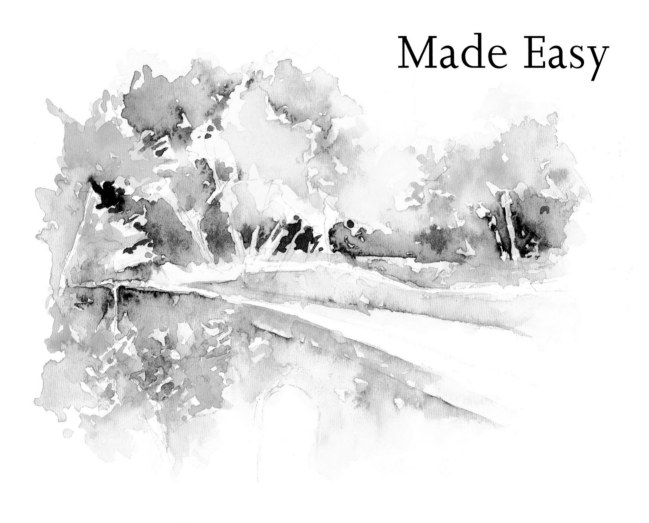

Watercolour Landscapes

Made Easy

Richard Taylor

B T Batsford Ltd, London

This book is dedicated to my son, Edward.

I wish to acknowledge the help and support given by my wife, Debbie, throughout the preparation of this book.

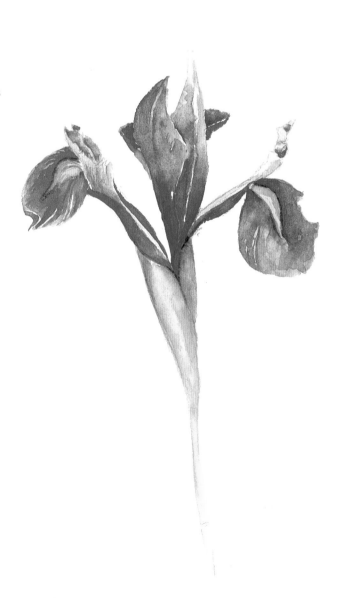

First published 1996

ISBN 0 7134 7955 8

A catalogue record for this book is available from the British Library.

Published by
B T Batsford Ltd
4 Fitzhardinge Street
London W1H 0AH

Printed in China

Contents

Painting Landscapes

My main aim in this book is to show how to paint the landscape effectively using simple techniques and a basic range of colours. Colour fills our everyday lives and is nowhere more evident than in the landscape, which can provide painters with an endless source of inspiration. Nature offers some of the most vibrant and exciting scenes imaginable, but you only need to see the dawn breaking in the countryside, with the mist hanging softly over fields, forests and rivers, to realize that it is also capable of producing moments of great beauty and tranquillity.

I choose to work in watercolours because I find the qualities of the paints perfectly suited to capturing a wide range of landscapes, from rocky coastlines and clifftop villages to leafy woodlands and sundrenched deserts, in different seasons, weathers and lights. Watercolours can produce exciting effects when applied with great intensity, washed over and allowed to bleed freely, forming their own patterns and colour mixes. They can also be used to record minute detail, such as a complex web of intertwining twigs among a nest of brambles, with great accuracy. They are portable as well as being inexpensive and extremely versatile. Their finest qualities, however, are best determined in the hands of the individual painter.

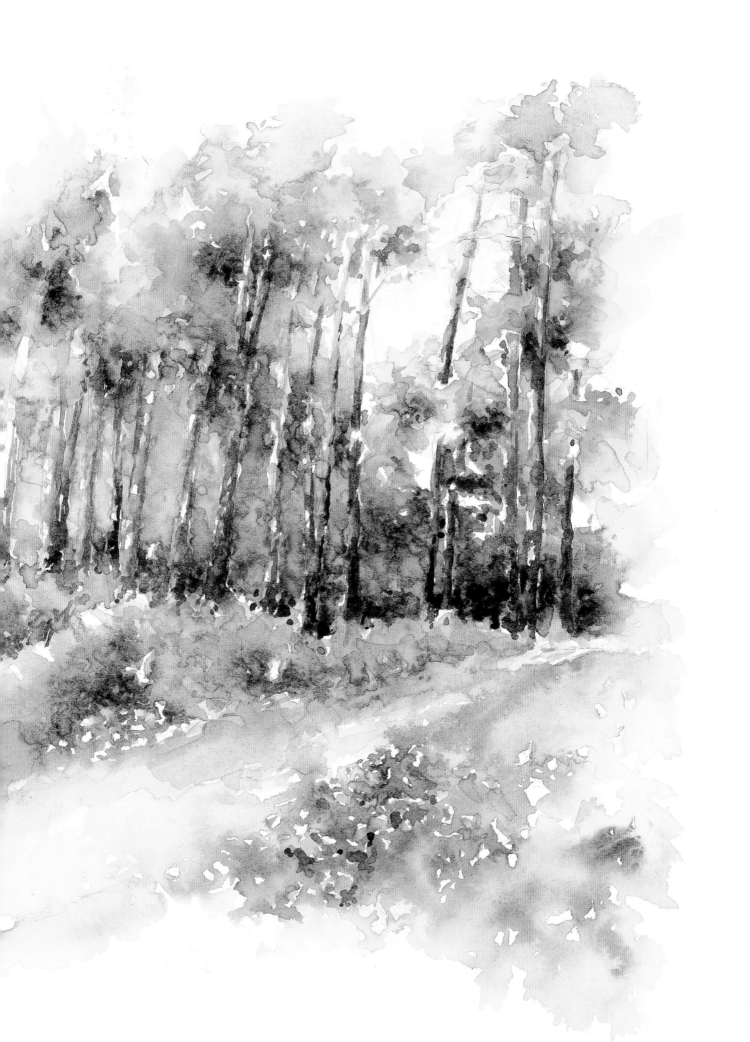

Methods of Working

A sketchbook is one of the most valuable pieces of equipment for a painter. A small pocket-size book is all you need to record useful details such as individual leaves which, when grouped together, make up the colours – especially the ground colours – of a scene.

Use your sketchbook to experiment with both paint mixes and brush techniques, gradually building up a useful catalogue of different colours and textures. Take it with you wherever you go and don't miss out on opportunities to paint small items such as richly-coloured berries or a flower with unusual or delicate petals. You will refer to these images again and again when painting landscapes. I came across the leaves and fungi shown opposite on a forest floor. In terms of shape, colour and scale they were simple to paint.

Throughout this book I will frequently refer to and show examples of 'sketchbook' studies. These studies are simple, spontaneous and are not necessarily drawn within a rectangular frame. They are, in other words, my own visual notes which I take home and use for building up a fuller picture at a later date.

You will often find that just a few light brush strokes suffice to help you capture the colour of the sky or the angle of the trees. But remember – your sketchbook need not be for public display, so you can experiment as much as you like, then close it up and keep it hidden away in your pocket if you wish!

Sketchbook studies

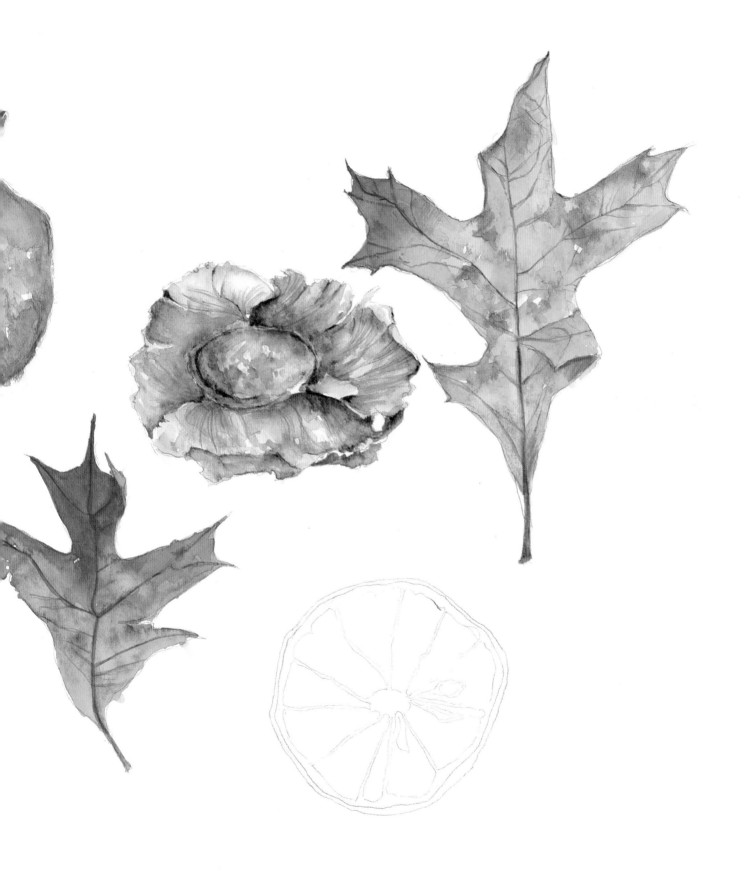

Anatomy
of a Landscape

This picture shows the 'anatomy' of a landscape and serves to introduce many of the terms and phrases that painters tend to use when discussing pictures and scenes.

The background is the very furthest, most distant part of the scene, often featuring an horizon. This is the least detailed part of the scene and usually the lightest in colour and tone. The middleground is, simply, the area between the background and the foreground. It should be slightly darker than the background, but will contain little detail. The foreground is the section of your picture which features the detail and the most colour. Shadows, leaves and branches, for example, might make up the key components of the foreground.

Negative Images
Light objects such as white fences, bare branches or twigs that stand out against a darker background are referred to as negative images.

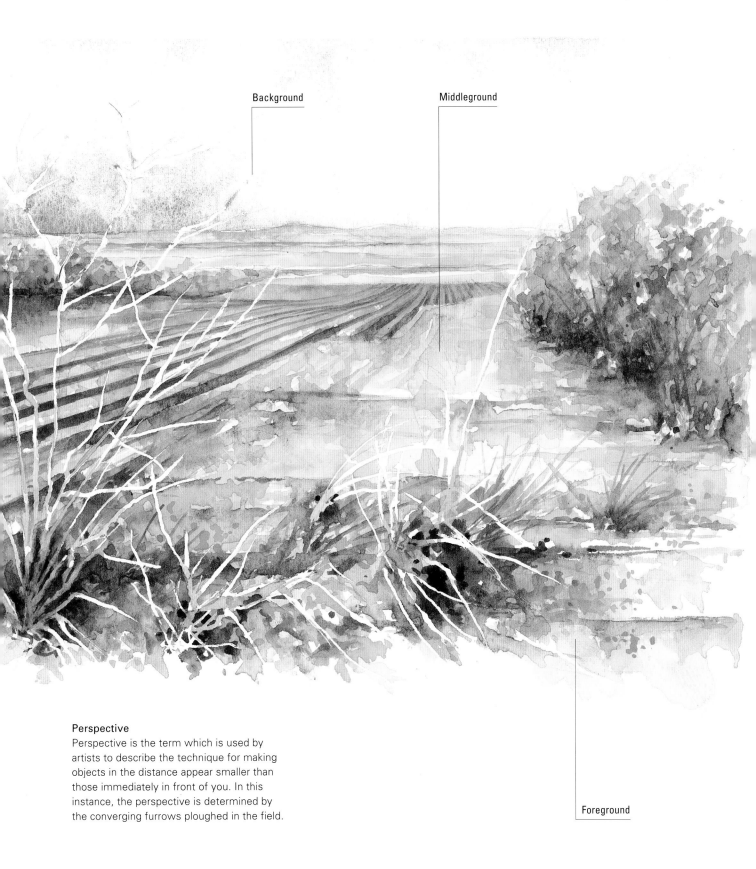

Background

Middleground

Foreground

Perspective

Perspective is the term which is used by artists to describe the technique for making objects in the distance appear smaller than those immediately in front of you. In this instance, the perspective is determined by the converging furrows ploughed in the field.

Equipment

To make a start, you will simply need a brush, a set of paints and some watercolour paper. As your skills develop, you will probably wish to add to and adapt your palette and to increase your range of brushes. At first, however, my advice is to stick to the basics.

I personally find a tin watercolour set to be invaluable. These sets provide room mainly for pan paints, but you can nearly always fit a tube or two in the middle. They will often come complete with a small retractable brush and the lids serve as a mixing palette. The more expensive ones sometimes have water containers attached. These tins can be slipped into your pocket for travelling or stored in a small drawer at home.

The range of colours in your paint set, rather than the type or make of paints, is probably the most important consideration of all – after all, painting is all about selecting the most appropriate colour for a particular scene or image. There are no exact matches for nature's colours to be found on artstore shelves, so you must choose your paints wisely, bearing in mind that by combining your basic colours you will be able to create a whole new set of variations. Too many paints will just lead to confusion while too few will be limiting. I would recommend choosing three variations of each of the most important colours, which are green, red, blue and yellow. These should include a 'cold' and a 'warm' tone as well as a mixer. There are also a few incidental colours which many painters find useful and which should make valuable additions to your palette. All these basic colour requirements will be examined in more depth over the following pages.

You will rarely need more than a total of three brushes for working on a picture. I tend to use a large brush (No. 9) for washing in a background, a smaller brush (No. 3) for painting in the bulk of the picture and a very fine brush (No. 0) for picking out details such as shadows and petals.

Brushes
A good-quality brush should hold sufficient paint to give a good, even wash across a sheet of paper. Sable brushes are traditionally thought to be the best, but synthetic brushes are much cheaper and nowadays run a very close second.

Pan paints
These are small, solid paint cakes that come in sets (refills are available). They give a thin translucent paint, invaluable for sketching and building up layers of watercolour washes.

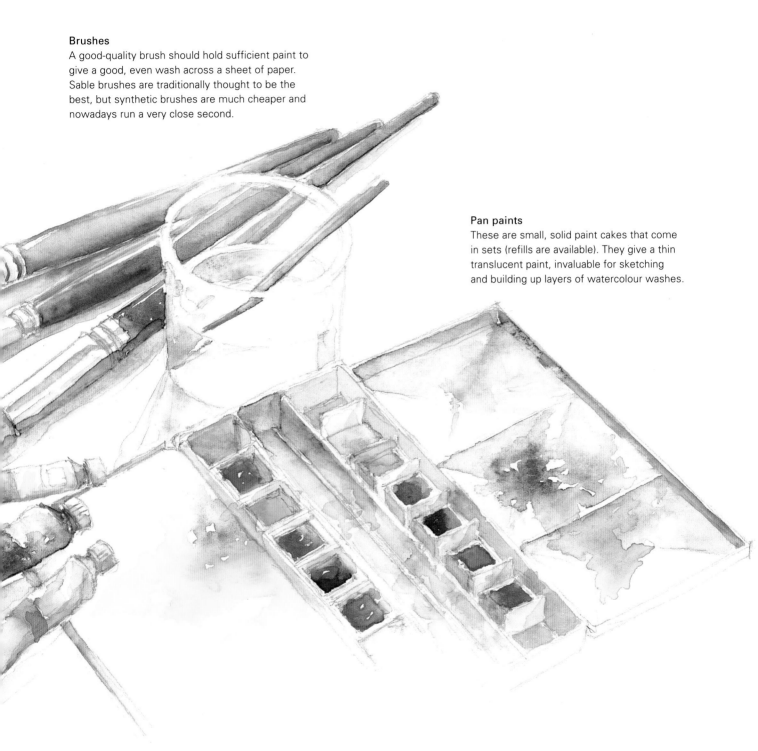

Tube paints
Tube paints can be squeezed on to a palette and are used to give intensity and body to the more watery washes produced by pan paints.

Paper

Watercolour paper must be able to absorb water and watercolour paint and yet still maintain its strength and flatness. It will usually be treated to several applications of paint so you should always try to buy the best quality. Watercolour paper is available in assorted forms. It is sold in large loose sheets, blocks and sketchpads. It is classified according to its surface texture and its weight. Below is a brief analysis of each of the main types to help you select the most appropriate for your purposes.

SMOOTH

This type of paper is manufactured with a hot press (hence the term HP by which it is sometimes known), which leaves the paper smooth and virtually textureless. It can provide a particularly useful surface on which to paint fine details, especially when you wish to paint within a line drawing.

NOT

Not paper (cold pressed) has a textured surface which is extremely well suited to everyday watercolour painting. This slightly rough surface ('tooth') enables you to achieve a wide range of interesting effects with watercolour paints.

ROUGH

As the name implies, this paper is highly textured and is, perhaps, best left until you have a little experience with watercolour as it can almost take control of the paint and brush strokes. But when you feel confident enough, rough paper can produce some striking results and is especially useful for large paintings and loose, free brush strokes.

WEIGHT OF PAPER

The weight and the thickness of paper are usually classified both in pounds (lb) and in grams per square metre (gsm). Watercolour paper starts at 90 lb (190 gsm) but this is quite thin and will 'cockle' (bend and twist) if it becomes too wet. I find 260 lb (550 gsm) a useful medium-weight paper which will tolerate most kinds of treatment, while 400 lb (850 gsm) is a real heavy-duty paper which will put up with any level of punishment.

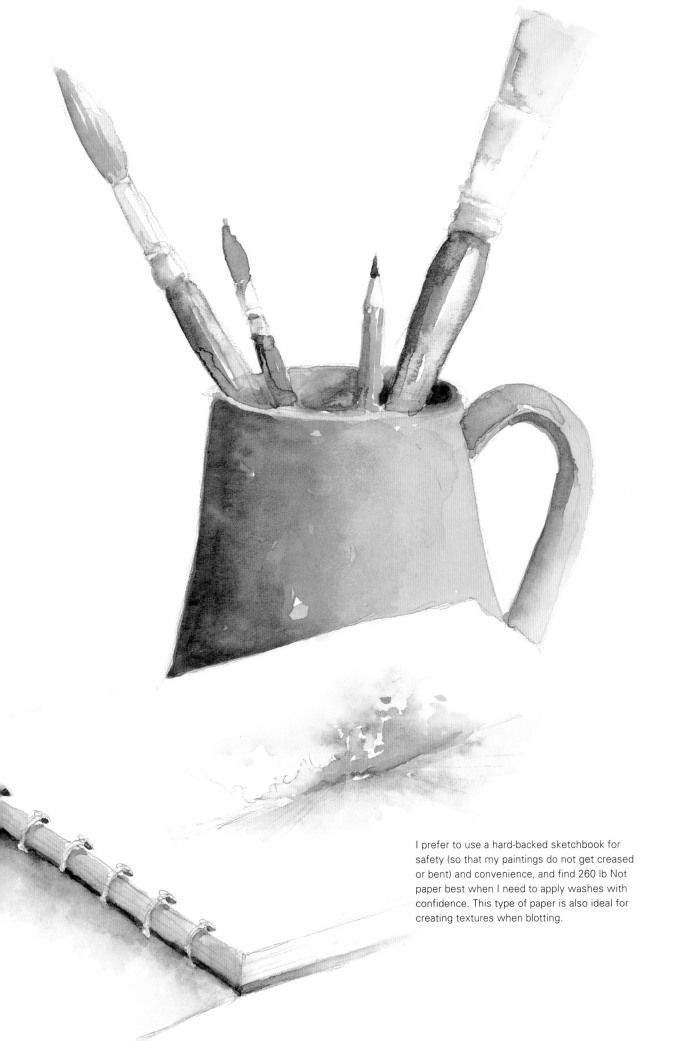

I prefer to use a hard-backed sketchbook for safety (so that my paintings do not get creased or bent) and convenience, and find 260 lb Not paper best when I need to apply washes with confidence. This type of paper is also ideal for creating textures when blotting.

Blues

Blue is an extremely valuable colour for underwashing (the first thin wash or application of paint), for landscape backgrounds and, when used as an undercoat, it can tip the balance between warm and cold scenes. While blues are generally used for skies and backgrounds, they also make very good mixers and can often be used to darken greens in the landscape.

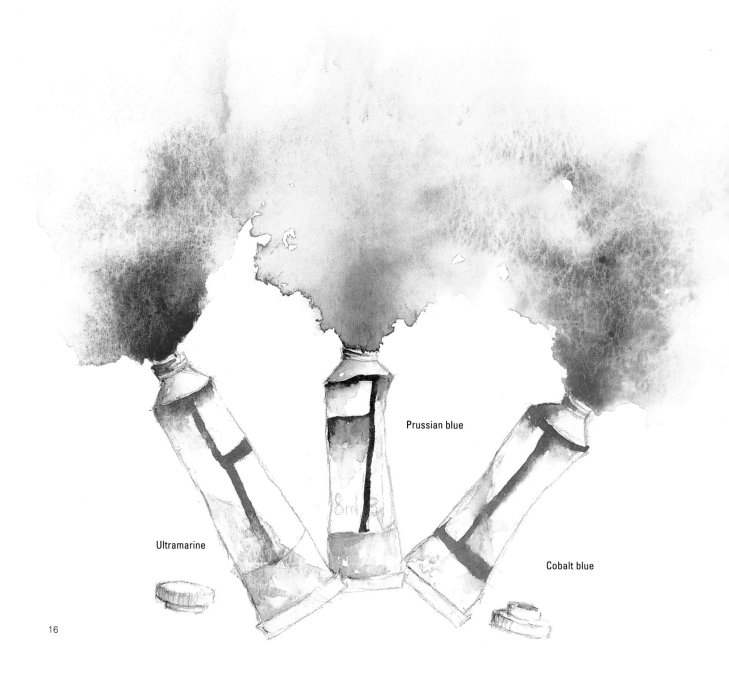

Prussian blue

Ultramarine

Cobalt blue

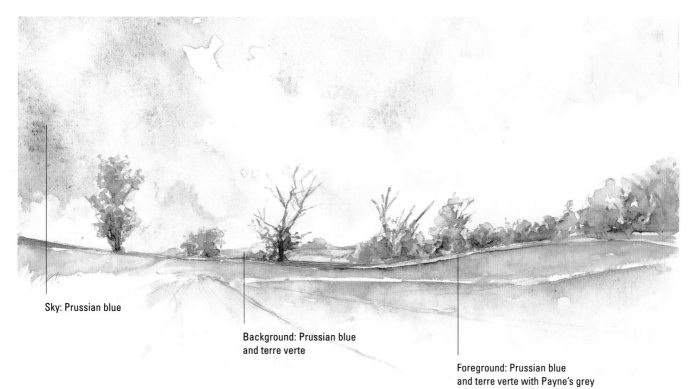

Sky: Prussian blue

Background: Prussian blue
and terre verte

Foreground: Prussian blue
and terre verte with Payne's grey

This stark winter landscape exposes the cold
qualities of blue paints.

ULTRAMARINE

This is perhaps the most important shade to include in your range of
blues because it has particular value in warm landscape work and it is
fair to say that most landscape painters do tend to stick to fairweather
scenes. Ultramarine is a good, general-purpose blue (although it is
inclined towards violet) which is well suited to covering relatively
large areas and which maintains its strength and brightness while
you work.

Prussian blue

PRUSSIAN BLUE

This was originally developed as a dye. The synthetic paint version of
today is a strong cold blue which can dominate a scene very easily, so
it should be used with care. Used thinly Prussian blue is an ideal colour
for painting shadows and it is equally well suited to adding atmosphere
to wintry or stormy landscapes.

Payne's grey

COBALT BLUE

It no longer contains arsenic as it did during the 1700s and is, today,
a transparent, cool, mid-blue somewhat like ultramarine but a little
thinner and lighter. It is particularly useful for cloudy skies where a
fresh, maybe chilly feel is required, but not quite for the impending
storm that Prussian blue might be used to depict.

Terre verte

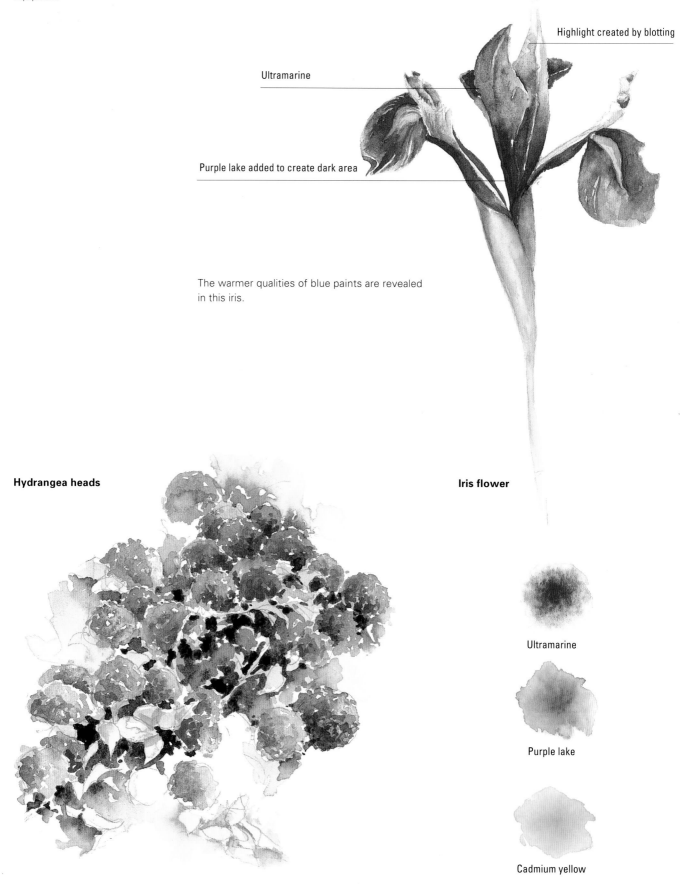

Highlight created by blotting

Ultramarine

Purple lake added to create dark area

The warmer qualities of blue paints are revealed
in this iris.

Hydrangea heads

Iris flower

Ultramarine

Purple lake

Cadmium yellow

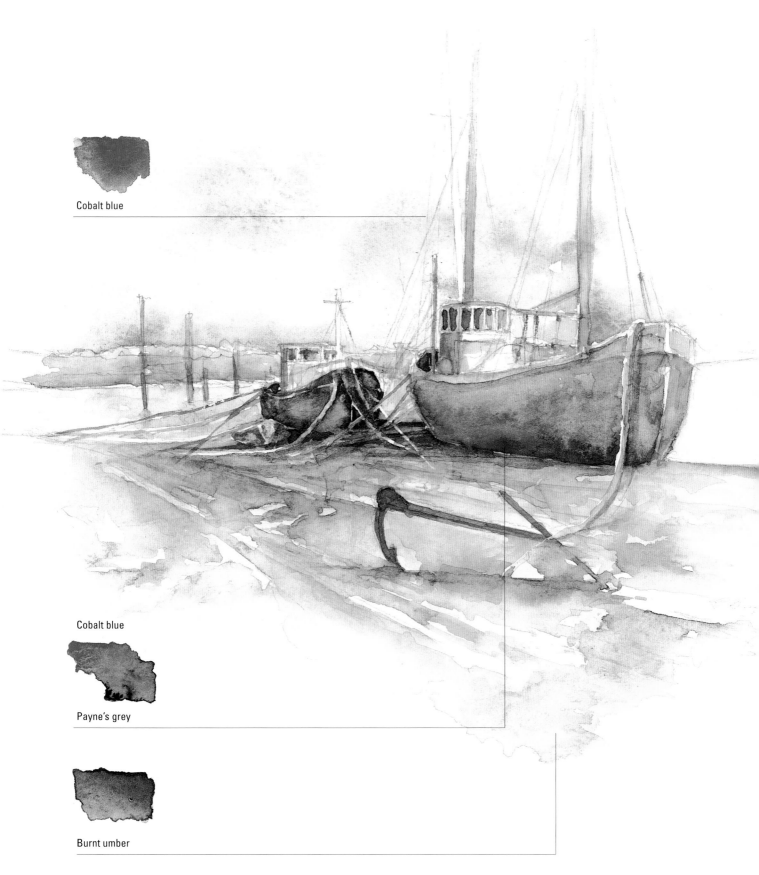

Cobalt blue

Cobalt blue

Payne's grey

Burnt umber

Yellows

Yellow paints are those most often used for underpinning landscapes. They can create the impression that a scene is glowing in the morning sunlight or that it is oozing evening dampness just as effectively. From the brightest cadmium to the more natural earth colours of the ochres and siennas, yellows are invaluable in establishing the nature, tone and atmosphere of a landscape.

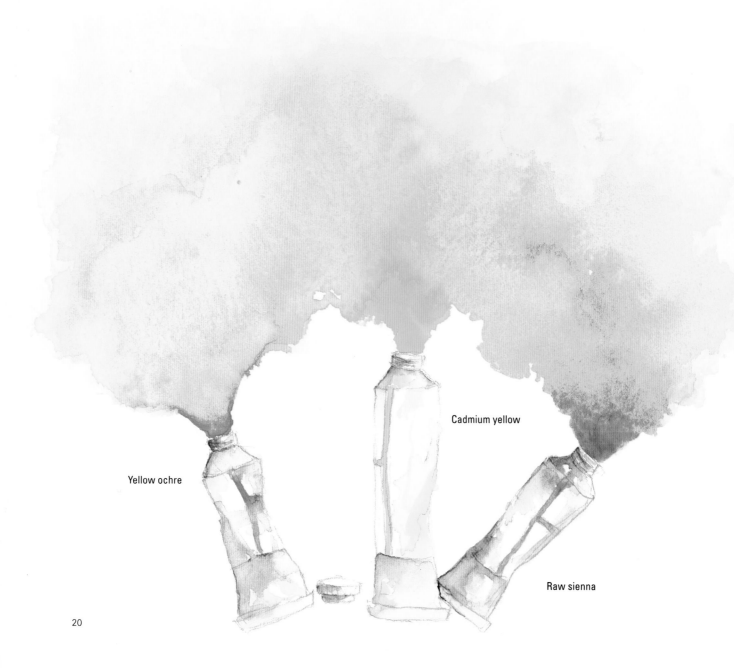

Cadmium yellow

Yellow ochre

Raw sienna

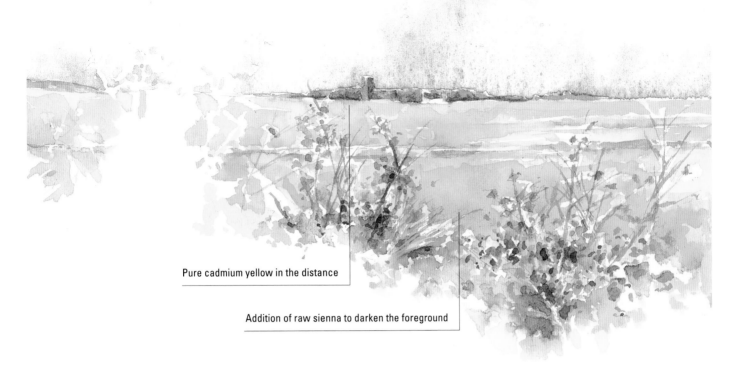

Pure cadmium yellow in the distance

Addition of raw sienna to darken the foreground

CADMIUM YELLOW

This is a strong warm colour, bordering on orange, with good covering qualities. This means that a little paint will go a long way, maintaining its strength well. Cadmium yellow is not often used for mixing but is appropriate for short, sharp bursts of colour, particularly for flowers. It should be used sparingly, but it is an essential component of the landscape painter's palette.

Cadmium yellow

YELLOW OCHRE

A natural earth pigment coloured by sulpherous iron oxide, yellow ochre is found in the mountains of Europe and has been used for underwashing landscapes since at least the year 1400. It is a thin transparent paint, which means that no matter how thickly it is applied, the tones and the textures of your sheet of paper will still show through. It can alter the tone of another colour slightly if washed thinly across it. This technique is referred to as glazing and usually produces a cold feel. Suggested uses are as an undercoat for ploughed fields and for rocks and cliffs. It is best painted on to rather than used as a mixer, although, as with many other colours, from time to time I do mix it with green on the palette.

Raw sienna

Sap green

RAW SIENNA

This is a warm yellow-brown paint that also has its origins in volcanic mineral seams. Unlike yellow ochre, however, it is particularly useful for mixing – either with ground or foliage colours. It may also be used as a landscape undercoat in the same way as yellow ochre but it will always give a warm base to paint upon. It is, perhaps, the most valuable of the yellows because of its flexibility and you will find it mentioned on many of the following pages.

The many different yellow tones contained within the daffodils and the sunflower head were discovered through close and careful observation. Both the sunflower and the small bunch of daffodils were recorded as sketchbook studies and they serve as permanent references which can be returned to whenever I need to check on the colour combinations and tonal ranges I used to capture them.

Both types of flower hold great natural beauty which, I believe, comes from the combination of warm and cool tones. The outer petals of the sunflower were painted with a slight touch of green, while the inner head required the addition of raw sienna and just a touch of cadmium orange (a colour I rarely use and reserve only for light touches where appropriate) to allow the sketch to glow as if with the warmth of the sun. The daffodils required similar treatment but to record these I used more water to thin the colours and to give the petals the appearance of greater translucency.

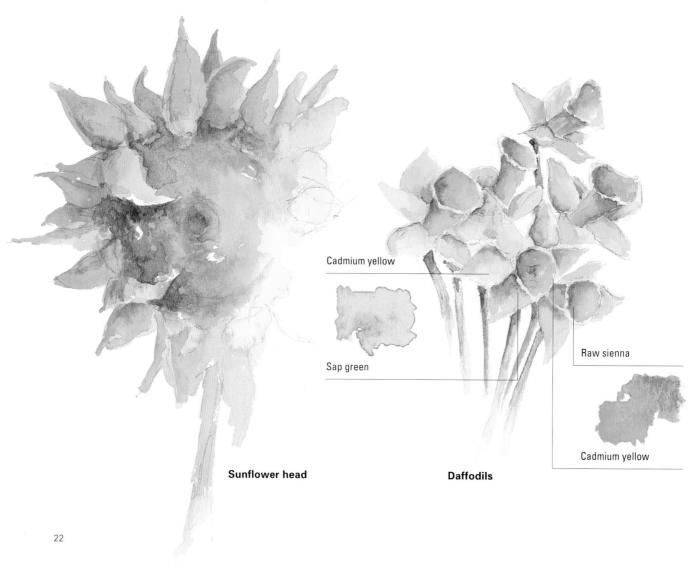

Cadmium yellow

Sap green

Raw sienna

Cadmium yellow

Sunflower head **Daffodils**

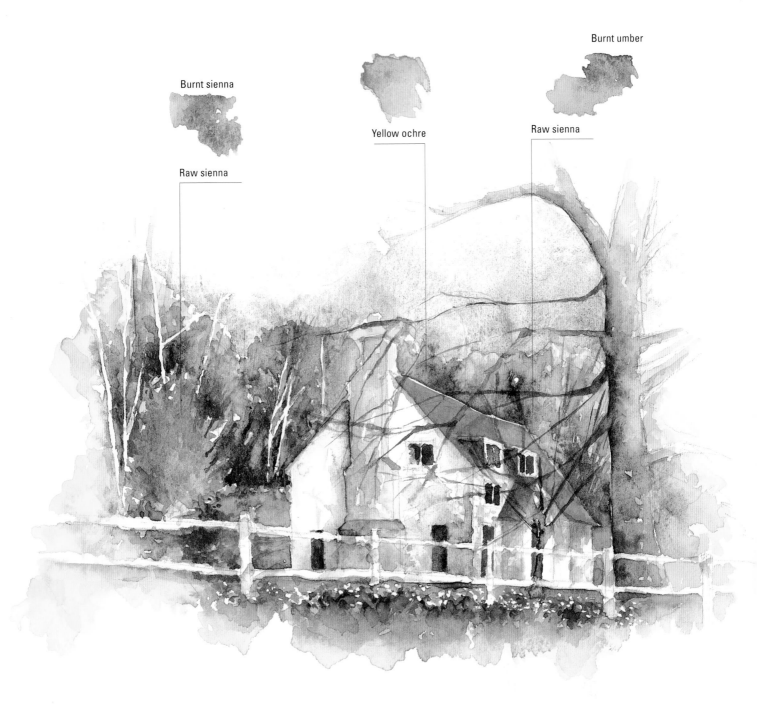

Burnt umber

Burnt sienna

Yellow ochre

Raw sienna

Raw sienna

SKETCHBOOK STUDY

This scene has been built up with a combination of yellows, including cadmium yellow for the daffodils, and the earth yellows (siennas and ochres) for the colours of the trees as well as the ground in the sharp afternoon light.

The main purpose of the sketch was to record the effect of the lighting on the colours. The entire appearance of a landscape can be subtly altered by the quality of the light. Enjoying natural excesses such as bright powerful sunlight and dark brooding skies is, to me, both the pleasure and the challenge of landscape painting.

Greens

Greens are arguably the second most important range of colours after blues as they usually play a dominant role in a landscape. When painting landscapes, the blue you use for the sky should influence your choice of green paints.

It is also worth bearing in mind that no true match for any of nature's wide range of greens can be found in a tube or a pan. You will find that you need to experiment by mixing your green paints with umbers, ochres and siennas to achieve the right effects.

Sap green

Terre verte

Viridian

TERRE VERTE

This is a natural earth colour that is best used as a mixer. It has a cold bluish tint and mixes particularly well with viridian, which it softens, creating a well-balanced green, useful for any natural landscape or for distant foliage. Terre verte also provides a good underwash because of its thinness and weak covering power.

VIRIDIAN

A strong emerald green, best mixed with other colours to brighten them up, viridian is most suitable for painting man-made objects such as signs, garden furniture and painted woodwork.

SAP GREEN

Originally made from ripe blackthorn berries, sap green tends to be on the yellow side of the colour spectrum. It has a warm glow which makes it invaluable for general landscape painting, especially for trees, bushes and foliage. I find that I tend to use this paint more than any of the other greens, although I sometimes need to temper its warmth either by mixing it with another green or, more frequently, with a yellow, brown or blue.

This garden scene was awash with such an array of greens that it provided a wonderful exercise in mixing. It was a real challenge to create the right green for the right plant.

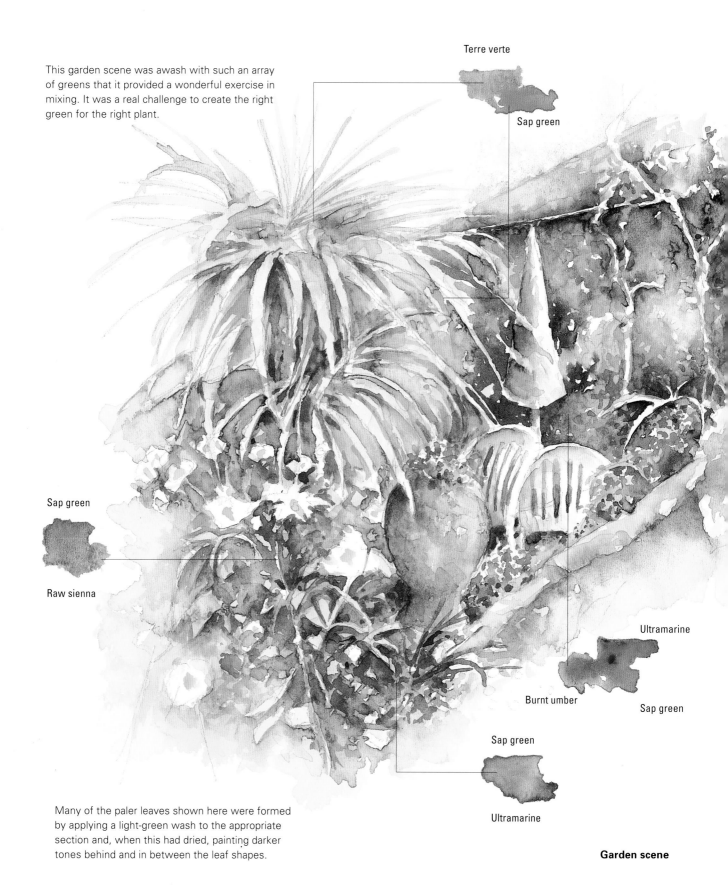

Terre verte

Sap green

Sap green

Raw sienna

Ultramarine

Burnt umber

Sap green

Sap green

Ultramarine

Many of the paler leaves shown here were formed by applying a light-green wash to the appropriate section and, when this had dried, painting darker tones behind and in between the leaf shapes.

Garden scene

Cadmium yellow

Sap green

This wild garden with its untamed foliage and a wealth of flowers of all varieties and colours proved one of the most challenging to paint because of the wide range of greens that needed to be mixed.

The technique I used here involved creating a base green of very watery terre verte and sap green, which was washed loosely on to dry paper using a No. 9 brush. The reason for working with a large wet brush on to dry paper was to enable some natural-looking visual breaks to occur among the greens. As you apply wet paint to dry paper, the paint will not bleed freely (as it would on wet paper) but will go where it is put by your brush. As several applications were required in this case, and many brush strokes were used, some small gaps occurred where the white paper showed through. I left these white to give the impression of highlights or simply to emphasize tonal differences between the plants. You can see this technique particularly on the huge palm plants at the top of the sketch.

The mixture of terre verte and sap green provided a good base of pale colour on which to build, but it was important to judge the strength of this first application carefully as the translucent quality of watercolour paints means that the underwash always shows through subsequent layers. The next stage was to sit back and enjoy the challenge of trying to recreate the variety of greens in the garden with just a small selection of watercolour paints.

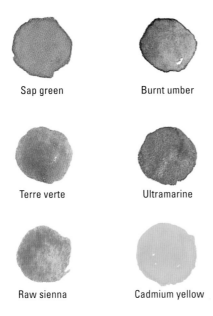

Sap green Burnt umber

Terre verte Ultramarine

Raw sienna Cadmium yellow

Red

Reds occur less frequently in the landscape than the colours considered so far. They are used to add highlights to scenes or to pick out specific flowers or artificial details rather than as an underwash or a base. Reds are often found in plants, flowers and brickwork, which when painted against a country or garden scene, can look particularly attractive. Reds are also an essential colour in the composition of sunset scenes, which, because of their beauty and the scope they provide for experimenting with brush technique and paint mixes, artists find especially inspiring. But beware – a tiny amount of red paint dropped on to wet paper is usually sufficient because it will spread, creating the effect you need.

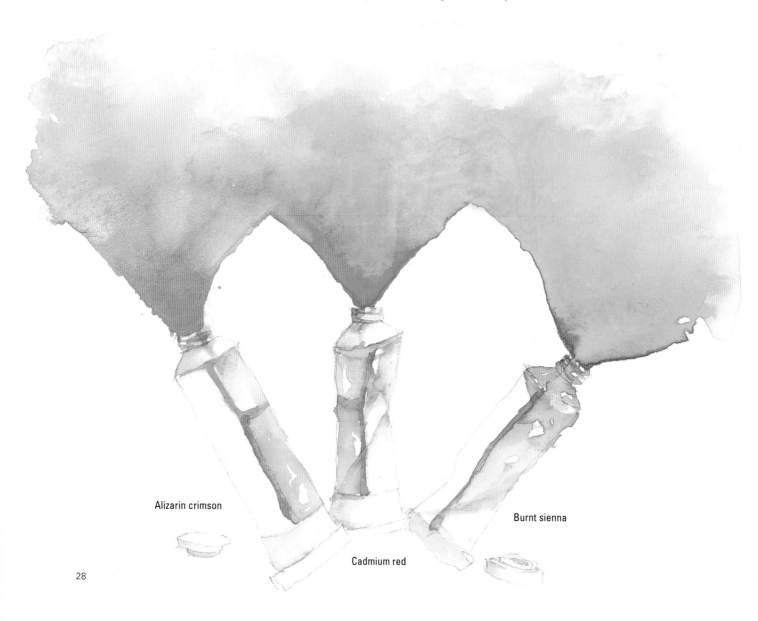

Alizarin crimson

Cadmium red

Burnt sienna

The deeper reds of the poppies in this field were achieved by the addition of alizarin crimson to the cadmium red base colour.

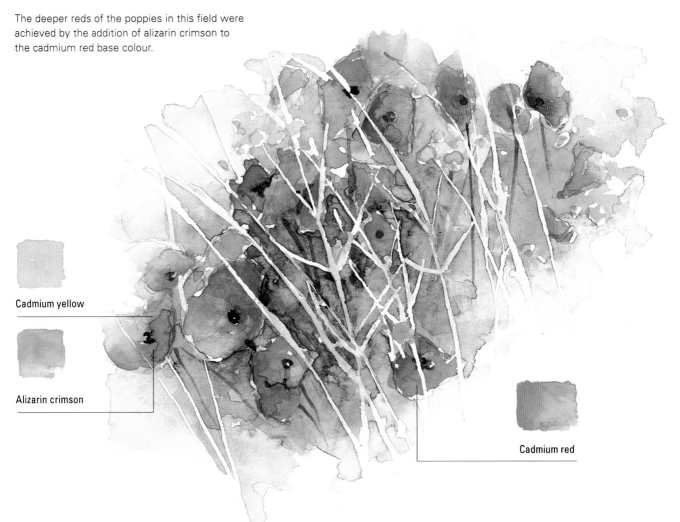

Cadmium yellow

Alizarin crimson

Cadmium red

CADMIUM RED

This is a particularly strong colour although it does lack the covering qualities of cadmium yellow. It is thinner in a wash and soon turns pale when water is added. I have found it to be one of those colours that look good in the pan, but which can be disappointing when applied to paper and allowed to dry. It does, however, provide a useful base colour for building up images of geraniums, poppies and other red flowers.

ALIZARIN CRIMSON

This is a cold red of little value to the landscape painter in isolation, although it is quite a good mixer, especially with cadmium red with which it combines to produce a more natural, deep colour. It is also very useful for painting reflections of red objects in puddles.

BURNT SIENNA

This is a rich, luminous, warm, reddish-brown, ideal for underwashing brickwork and wood. It covers well and, being a natural earth colour, is a useful landscape paint. You will probably notice that burnt sienna is a favourite colour of mine. An excellent mixer, it is equally valuable for washing over other colours (especially to give shadows a little warmth).

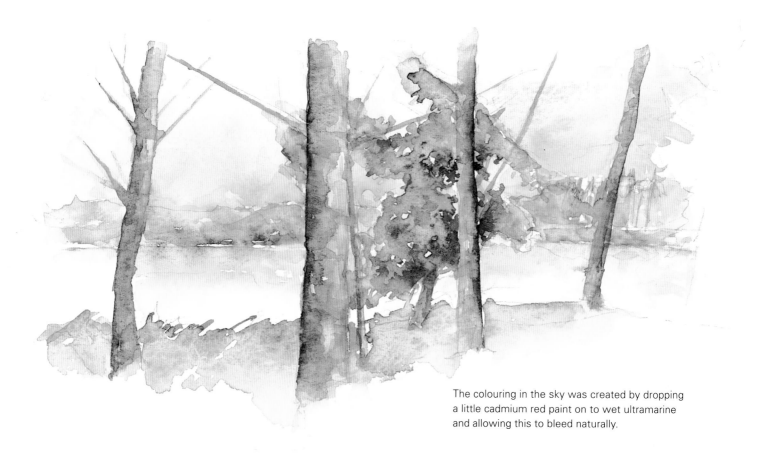

The colouring in the sky was created by dropping a little cadmium red paint on to wet ultramarine and allowing this to bleed naturally.

Red paints will nearly always need mixing with another colour – either another red, or with yellow or orange – in order to achieve the most natural tone possible. Mixing can either be done in the palette or by adding paint from your palette to wet paint already on the paper (using the technique known as wet into wet) or, finally, by painting on to a dry base colour.

The pot of geraniums opposite successfully illustrates the technique of mixing reds. A base colour or undercoat of cadmium yellow was first applied to the flower heads and allowed to dry. Cadmium red was then painted on to this and, as it dried, the finer qualities of the cadmium colours began to show. Rich warm tones appeared as a result of this watercolour alchemy, creating the perfect geranium.

Reds also mix well with each other. You will often find that darker reds are best combined with another red as with the poppies shown on page 29 rather than with another colour altogether.

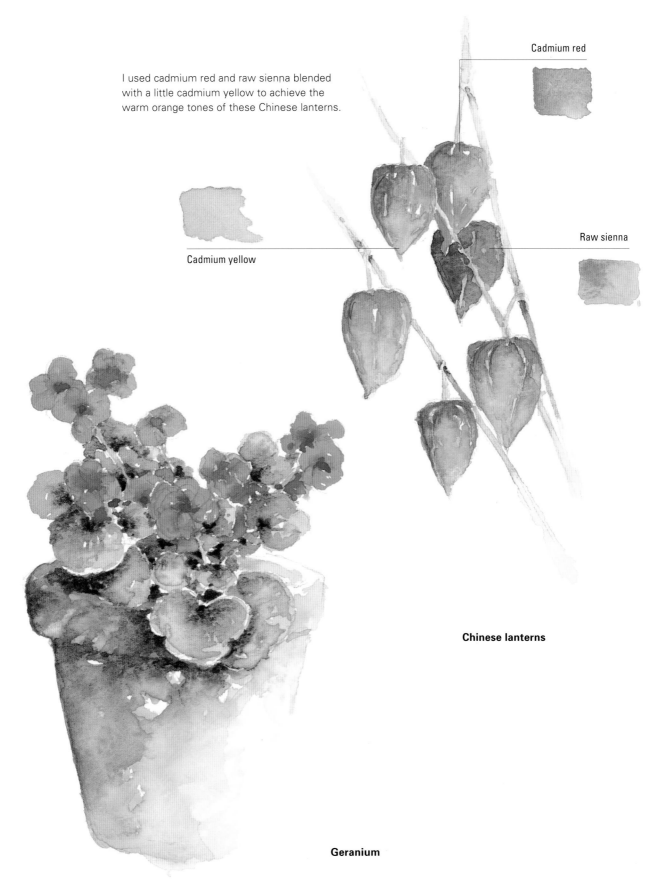

Cadmium red

I used cadmium red and raw sienna blended with a little cadmium yellow to achieve the warm orange tones of these Chinese lanterns.

Raw sienna

Cadmium yellow

Chinese lanterns

Geranium

Other Useful Colours

I rely heavily on the colours described over the last few pages, but no painter's palette should be rigid and unchanging. I have refined my own many times and am now satisfied with it after years of experimentation.

There are, of course, a few paints that do not fit easily into a particular category. I include five of these colours in my own palette.

PERMANENT MAUVE
A soft, warm colour which makes a natural companion for ultramarine, permanent mauve has a strong blue bias. I sometimes mix it with purple lake when painting flowers seen in window boxes and hanging baskets.

PAYNE'S GREY
This is a synthetically manufactured combination of ultramarine, black and some colder blue tints. It is useful for washing on to shadows of cold or neutral tone and for buildings or concrete. Apply it sparingly, as any paint with an element of black can easily flatten a scene.

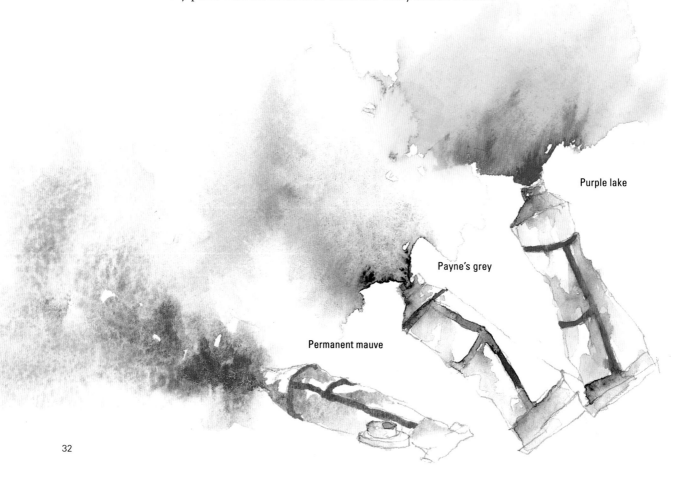

Purple lake

Payne's grey

Permanent mauve

PURPLE LAKE

I use this warm colour for washing over pictures to create an impression of sunlit radiance. It is also suitable for painting shadows on warm days when the sun is high in the sky.

BURNT UMBER

This is a warm dark brown which I use chiefly for mixing. It is a little too intense for underwashing a landscape, but is a necessary addition to the overall tone of a scene particularly where bare earth, trees and woodlands abound.

CADMIUM ORANGE

The inclusion of this colour in my palette is not the result of laziness even though it is simply a combination of cadmium red and cadmium yellow. Having it ready prepared saves time as it is a very useful colour for recording the warm appearance of fruits, and serves as an excellent base upon which to build a succession of translucent tones.

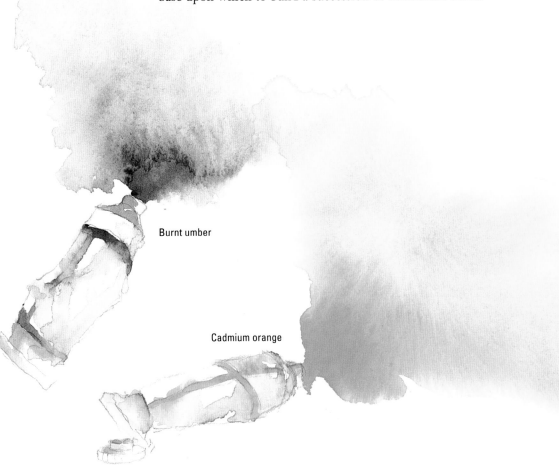

Burnt umber

Cadmium orange

chapter three

Basic Landscapes

This chapter shows you how to start painting landscapes. Before
you can begin a landscape picture, however, you need to have a
very clear idea in your head of exactly what you are going to paint.

It might be helpful at this point to mention that the term landscape
is a very general word that artists use to describe a wide range of
outdoor scenes or views that are generally well away from towns
or cities. Many people immediately think of open fields with vast
skies above and rolling hills stretching into the distance as perhaps
the most obvious example of a landscape, but there are countless
other attractive, dramatic and unusual scenes such as a small
wood, the corner of a ploughed field or a long, windswept beach,
all of which can provide the artist with inspiration.

Your primary consideration is what to include and what to leave out
of your painting. There are no instant answers to this dilemma –
experience will help you to select a scene and teach you how to
focus on the most significant areas within it whether from close up
or from a distance. But there are a few techniques which should
help you to make a start. One particular trick that I often use before
starting to sketch a scene is to hold a 35mm slide (transparency)
mount at arm's length and to look directly through it. This provides
a frame through which to study the subject and pick out the main
features, making it possible to mask off the surrounding landscape
which might otherwise be distracting. Your attention will be drawn
to deep shadows, lines such as hedges and stone walls which will
help you to view the perspective, as well as strong shapes such as
branches and ivy-covered fences. Then decide whether to fade the
sketch out towards the bottom of the frame or to fill the whole
sheet of paper with paint and colour.

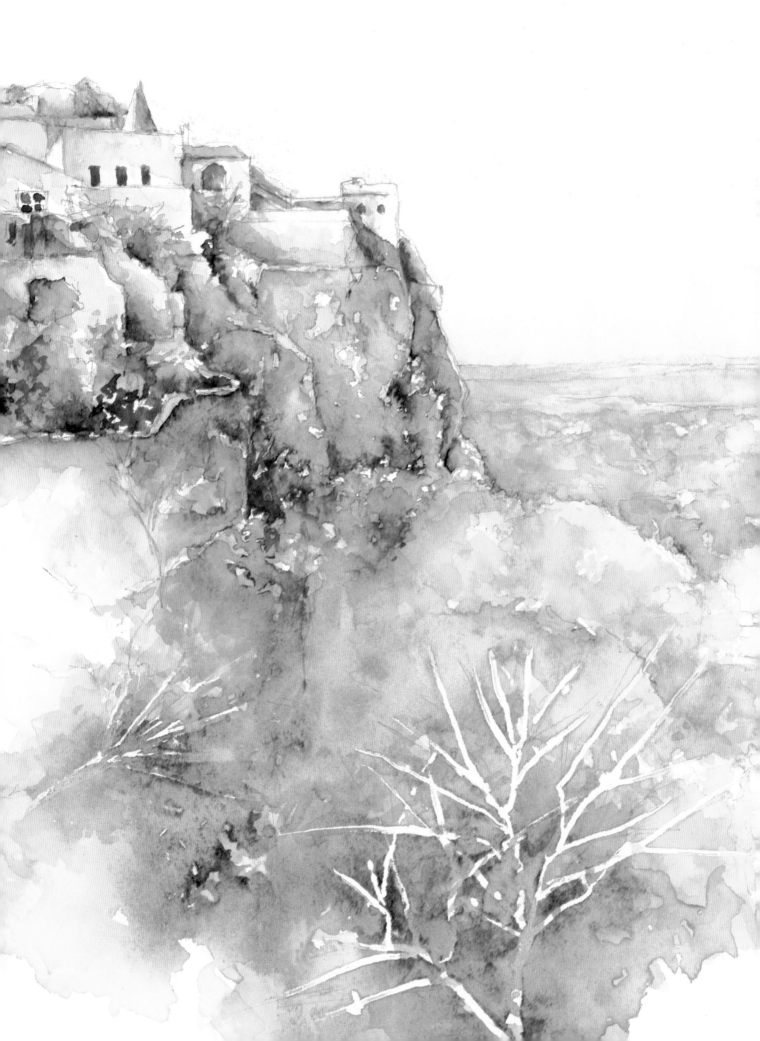

Project 1 **Methods**

The colours that make up a landscape can be found in a number of places, including the sky, the ground, water, leaves, flowers sand, rocks, and buildings to name but a few. Before starting work on a painting, it is best to familiarize yourself with these colours by selecting a few small areas or objects and recording them very quickly and simply in your sketchbook. This will help you to achieve more effective and realistic results when you start work on your actual painting.

Key landscape colours

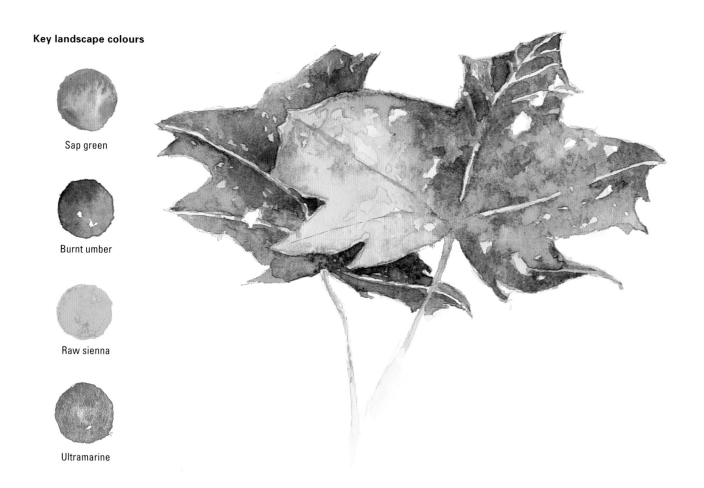

Sap green

Burnt umber

Raw sienna

Ultramarine

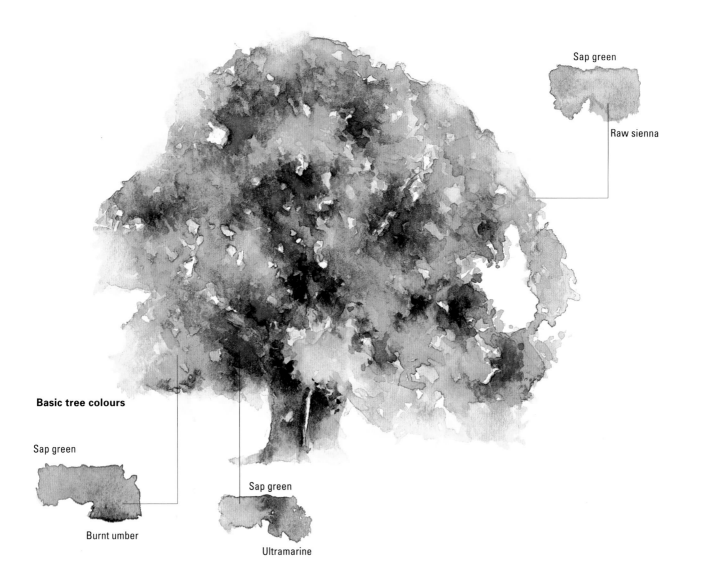

Sap green

Raw sienna

Basic tree colours

Sap green

Burnt umber

Sap green

Ultramarine

Leaves can provide a good starting point as they are often made up of more than one colour and they feature in many landscape scenes. Perfecting these colours in your sketchbook will give you a certain feel for the scene, allowing you to paint with much more confidence later. The natural earth colours sap green, burnt umber and raw sienna featured above tend to be most frequently used for painting leaves. Having painted a few individual leaves, you will easily be able to build up a more detailed picture of a tree using the same basic range of colours.

Trees in a landscape usually appear to feature three slightly different tones of a certain colour. Whether you are painting a cold bluish evergreen or a warm sunlit redwood you should be able to identify these three shades.

The lightest part of the tree is always at the top, where the sun catches a few lighter-coloured, shimmering leaves. The darkest parts can be seen in the shadows amongst the densest foliage, while the rest of the tree appears to be somewhere in between these two.

A country scene like this provides a painter with a perfect opportunity to practise mixing a range of natural-looking greens. Simply by looking carefully at every aspect of the scene, I was able to establish that the main colours I would need would be sap green, burnt umber and raw sienna for the foliage and a touch of ultramarine for the sky. Having selected my colours I could then start building up a picture (using a No. 3 brush) of the house nestling among the trees, with the rolling fields and hills in the background.

The sun was bright and the light strong, which meant that the sky would dictate the tone of the picture, with the deep shadows in the middleground exaggerated by the blue sky and the bright greenish-yellow highlights on some of the trees.

It might be useful at this point to consider the differences between sketching and painting with watercolours. It is not easy to explain, as both acts involve recording shapes and colour but the key difference between the two lies in the intention of the artist. Sketches are usually undertaken simply as a way of visual note-making, i.e. the artist's method of jotting down the features of a scene that seem to be most important, whereas a painting tends to be produced with the intention of creating something that can be mounted, framed or displayed. Of course, this distinction is highly subjective and very flexible, and what represents a polished, completed picture to some may suggest a mere sketch to others and vice versa.

On-site sketch

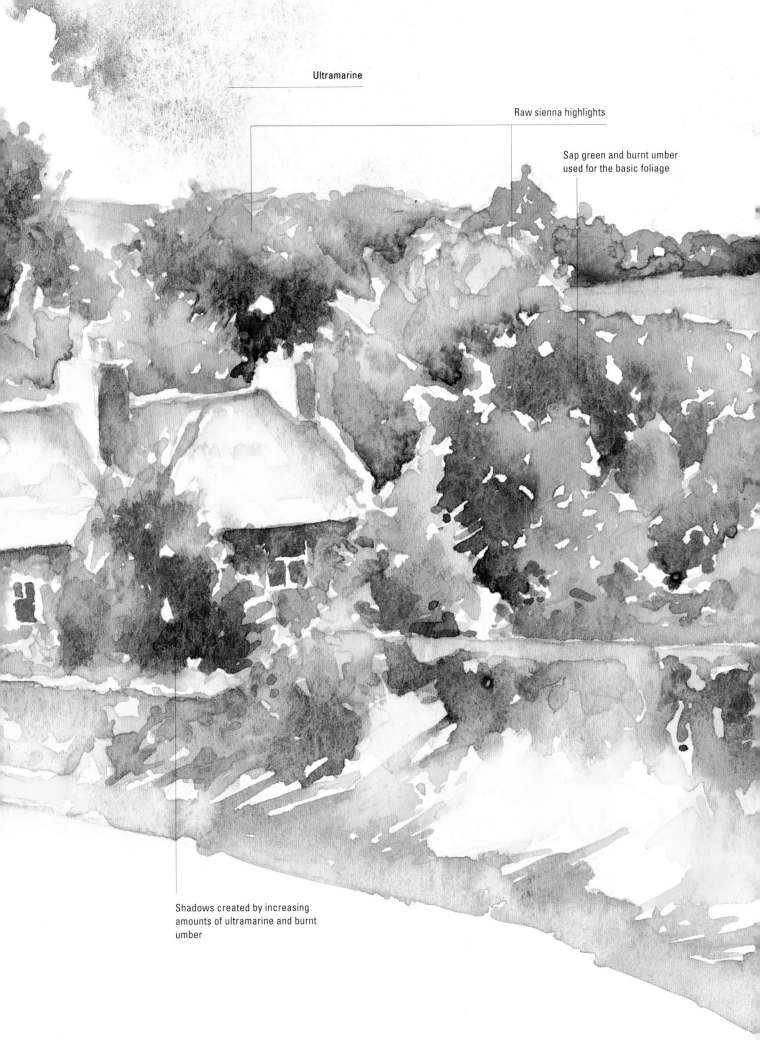

Ultramarine

Raw sienna highlights

Sap green and burnt umber
used for the basic foliage

Shadows created by increasing
amounts of ultramarine and burnt
umber

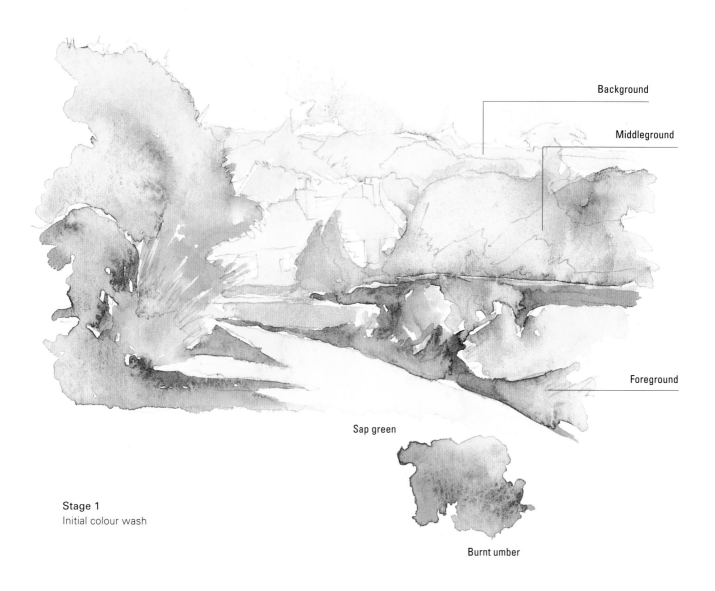

Background

Middleground

Foreground

Sap green

Stage 1
Initial colour wash

Burnt umber

Before beginning this stage, I dampened the surface of the paper by brushing some water on to it. A large brush is particularly suitable for this as it holds the water well. As the water soaked into the paper, I mixed the base colours, sap green and burnt umber, and then applied them quickly to form the rough shapes of the country cottage, the trees and the road. I kept the greens in the far distance lighter than the greens in the foreground where the final details would eventually appear. Note that it is almost always the case that the background appears lighter than the foreground in a landscape. The paint bled freely on to the damp surface, helping to establish colour continuity and avoiding clumsy, harsh breaks between the trees.

I allowed the paper to dry thoroughly before starting the second stage, which involved painting in the shadows and other details. I used sap green mixed with ultramarine and with burnt umber for the shadows as you can see below. When working on dry paper the paint will not bleed although it may run just a little. I gradually worked at transforming the flat surface of the first green wash into a more recognizable scene, giving the trees a more three-dimensional appearance. The final touches were achieved by dropping a little raw sienna on to the tops and edges of the trees to provide contrast with the dark greens and to lift the overall scene.

Stage 2
Shadows and highlights

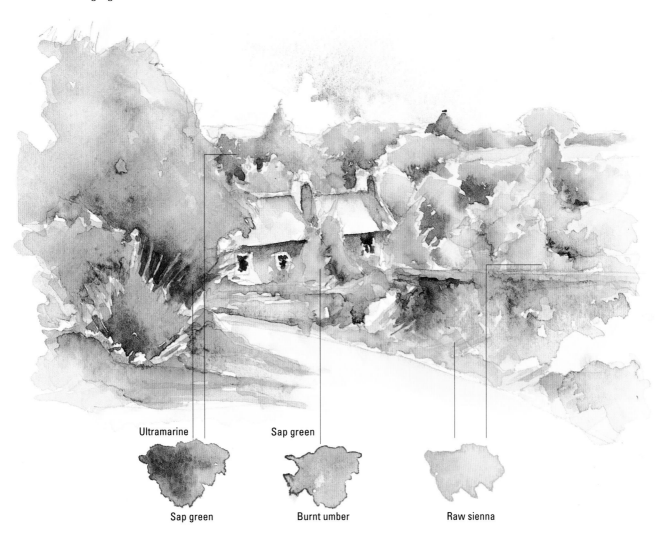

Ultramarine

Sap green

Sap green

Burnt umber

Raw sienna

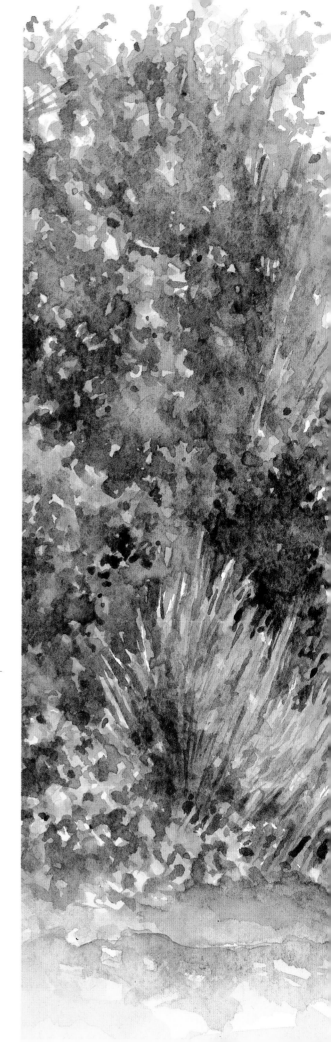

To produce this painting I referred closely to the quick on-site sketche shown on pages 38 and 39, which were based on general observations of colour and shapes.

The contrasts in light and shade are the key to making a painting such as this one a success. Shadows and patches of light create a 'push-pull' effect throughout the scene with the darker areas offsetting the paler groups of leaves, branches and clumps of foliage and appearing to push them forward.

Looking back to the sketches shown on the previous two pages, you can see that this landscape was painted using only four colours – ultramarine, burnt umber, sap green and raw sienna. This reveals the vast array of subtle variations of tone that can be achieved with a very basic palette.

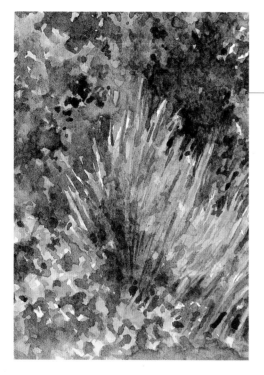

Shaded areas created by applying wet paint on to dry areas

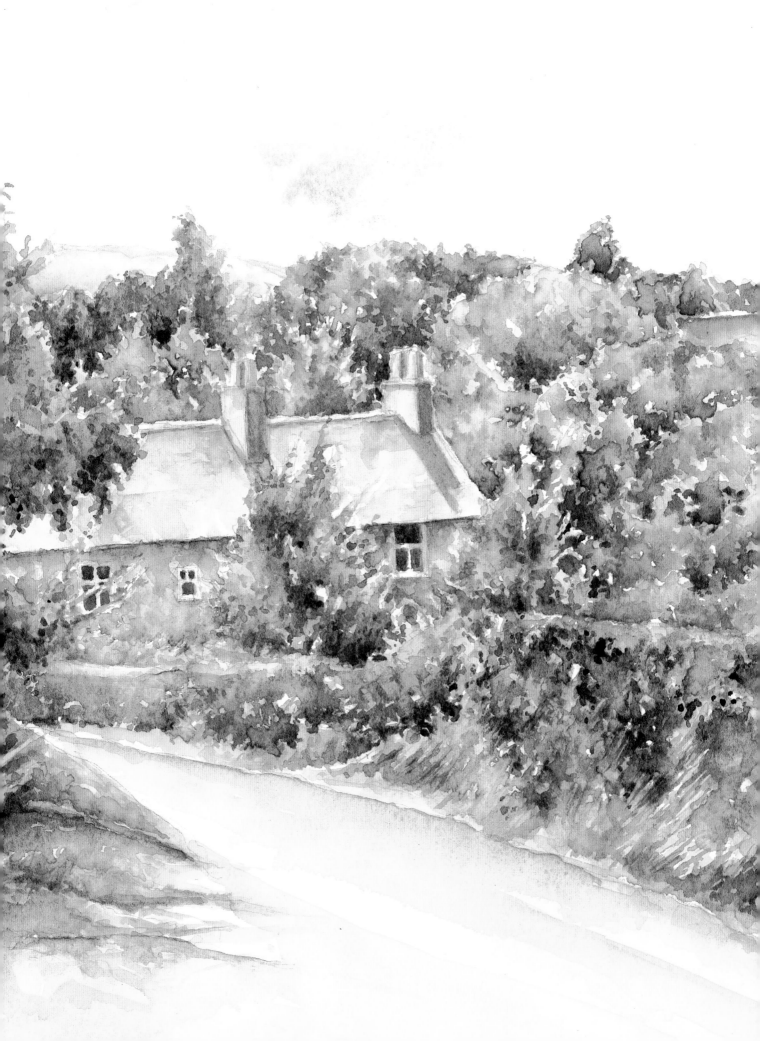

Hints and Tips

- Before you start a painting, study your scene carefully to familiarize yourself with the composition of the colours.

- Select a few objects to sketch and mix the paints in your palette to achieve the truest possible colour matches.

- Keep your colours simple when you first start painting. You can mix a vast array of tones with very few paints.

- When mixing colours it is best to start with the lighter colour in your mixing palette. It is easy to make a light colour darker by the addition of a small amount of the darker paint. It is very difficult, however, to make a dark colour lighter and most attempts to do so result in a muddy grey.

- A 35mm slide (transparency) frame makes an excellent viewfinder, allowing you to pinpoint the scene you wish to paint before you begin to sketch.

- When you first begin to sketch, it is probably best to use a pencil. With a B or 2B pencil you can vary the pressure with which you draw and you can make a few tentative lines to start with, knowing that you can easily correct any mistakes. As your confidence increases, you can move on to the more positive and permanent range of ink pens.

- Start sketching on to damp paper (this technique is known as painting wet into wet) if you are looking out across an open landscape. This creates a good flow of paint across the background and prevents clumsy breaks between trees which can make them look as if they have been painted individually.

- Don't forget that the colours and shapes of shadows will be determined by the colour of the sky and the quality of the light.

- Use good-quality paper for sketching – its strength and texture will make it more absorbent than cheaper paper and it will also help the paint to dry more evenly.

- It is advisable to stick to one brush for your first few pictures – a good No. 3 brush will allow you to treat a sheet of paper to a broad wash for the background as well as providing you with a relatively fine tip for painting in the details.

- Never use black in a landscape – it rarely ever appears as a colour in nature and therefore has no place in the landscape painter's palette.

Colour Palette for Project 1

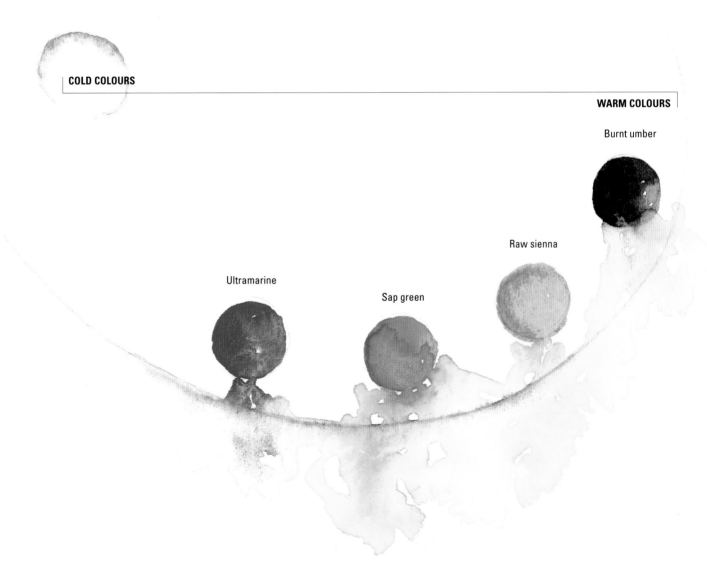

COLD COLOURS

WARM COLOURS

Burnt umber

Raw sienna

Ultramarine

Sap green

Project 2 **Rustic Scene**

Now that you are familiar with the basic colours, features and techniques of landscape painting, it is time to tackle a slightly more adventurous project.

While the techniques of sketching, which include underwashing, establishing any shadows and adding subtle highlights, rarely change, you may find additional colours sometimes need to be introduced to cope with the demands of the scene, especially if the lighting or atmospheric conditions are a little unusual.

In this particular case, I completed my sketch at the scene fairly quickly, using the minimum amount of colours although I intended to introduce a number of new colours later when working on the real picture. Remember that a sketch should act only as a reminder of the original scene rather than as a source of reference to which you should be bound slavishly.

My main aim in this sketch was to capture the atmosphere of the scene as it lay bathed in the soft, hazy light tinged with purple that was created by the rays of the late-afternoon sun. I selected a palette of colours such as purple lake, raw sienna and burnt umber, all of which possess the warm qualities found in the sultry Mediterranean landscape.

On-site sketch

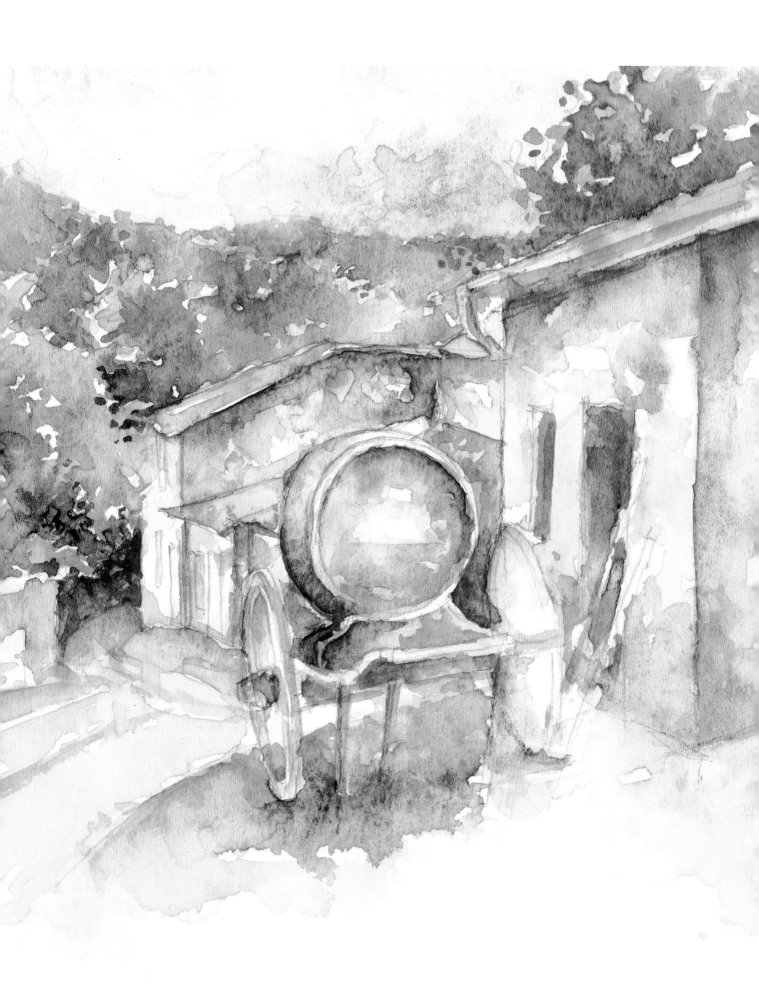

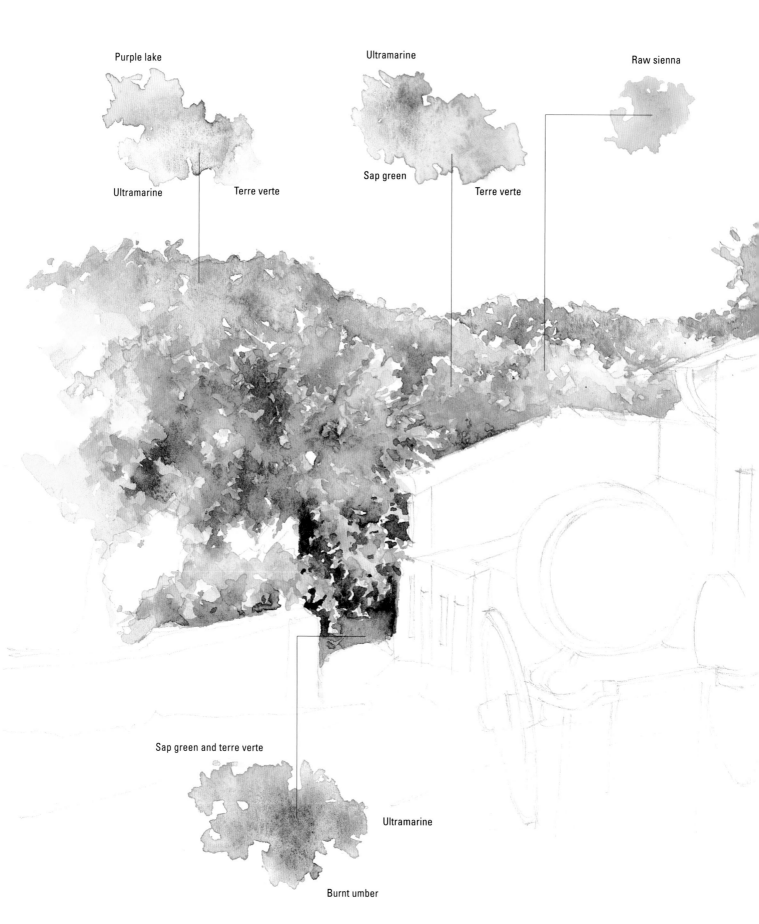

Purple lake

Ultramarine

Terre verte

Ultramarine

Sap green

Terre verte

Raw sienna

Sap green and terre verte

Ultramarine

Burnt umber

The background of this attractive scene was composed of a fascinating but subtle mix of blues, purples, greens and yellows. The most distant groups of trees appeared lighter than those in the foreground.

Ultramarine

I painted the background on to damp paper initially (using the wet into wet technique) with flowing brush strokes, creating a blend of soft colours. I applied blues and purples for the furthest hills to give them the impression of being away in the distance. Interestingly, atmospheric conditions always seems to give distant features of a landscape a bluish tint. A small amount of the cold shade of green, terre verte, added to the sap green base, as well as a hint of blue, also helped to enhance the effect of distance, while the colour purple lake provided the crucial element of warmth. Although mixing cold and warm colours together might seem to be a contradiction, in this case, it produces just the right effect.

Purple lake

Raw sienna

Sap green

The deep shadows towards the bottom of the wooded area were intensified by the addition of burnt umber and ultramarine, the brown giving strength and depth to the blue.

Terre verte

Burnt umber

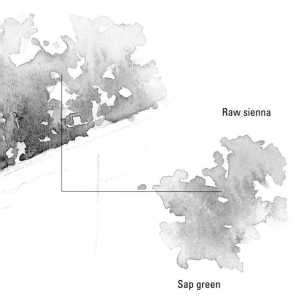

Raw sienna

Sap green

Stage 1
It is important to achieve a free flow of colours between background and foreground to maintain visual continuity.

Burnt sienna

Raw sienna

Purple lake

Ultramarine

Burnt umber

I needed to emphasize the warmth of the day through the shadows. Shadows cast on to buildings and other solid objects require different treatment from those cast on foliage. The dark tones to be seen dotted in the middle of a group of trees give way to much more clearly defined, sometimes angular shapes which often need more considered painting. If light is harsh and direct, a shadow will often have a rather sharp edge to it, while if the light is soft and diffused, the shadow will gradually fade out and become blurred at its edges. Allowing the paint to bleed by itself is the watercolour technique which enables you to give shapes and outlines an indistinct, slightly hazy look.

At this point it is appropriate to explain the technique of blotting which involves using either a small sponge or a piece of kitchen roll, which is my personal preference. Wet paint can be blotted gently around the edge of a bleed. This prevents a hard edge or watermark occurring and allows you to blend colours more naturally. You will find this technique particularly useful when trying to build up a pattern of textures.

The rim of the barrel was created by using the tip of the brush to paint a dark line around the inner edge. Then, with clear water only, the paint was 'pulled' towards the centre and blotted.

Ultramarine

Purple lake

Burnt sienna

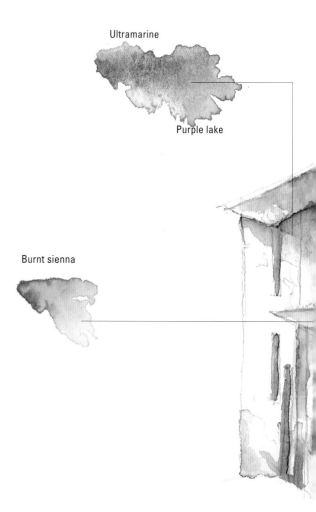

Stage 2
The texture of the buildings was created by successive washing and blotting with a range of purples and oranges. The act of dabbing a piece of rough kitchen roll on to a sheet of textured paper produces a rough, stone-like effect.

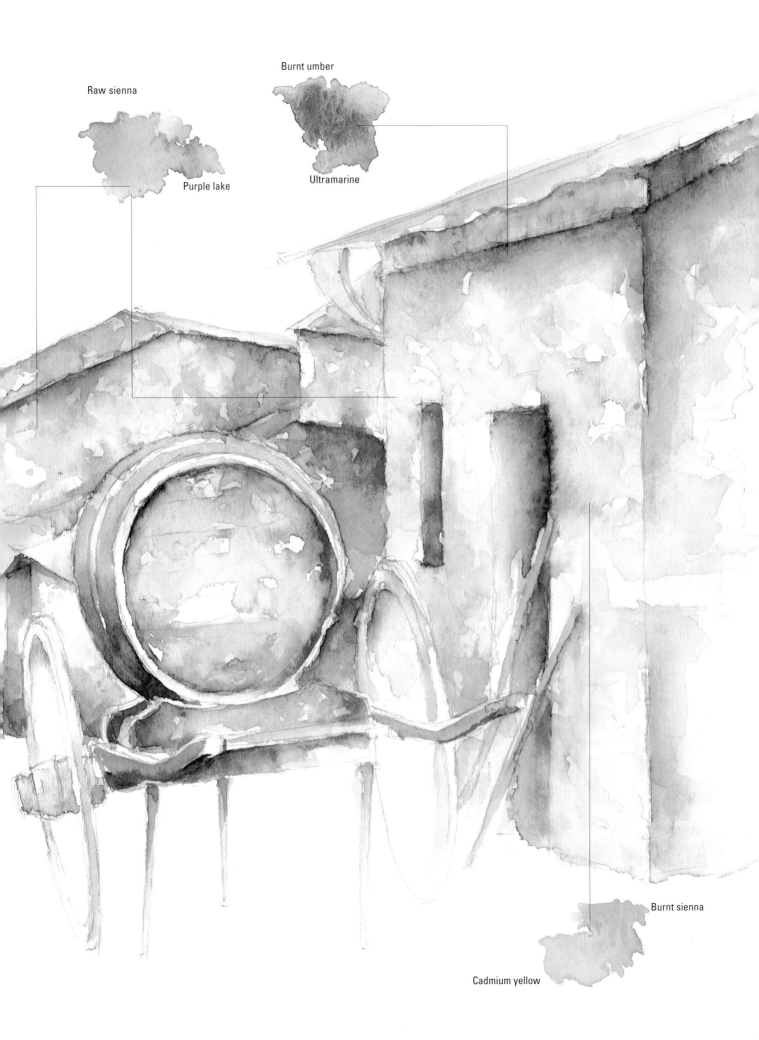

Raw sienna

Burnt umber

Purple lake

Ultramarine

Burnt sienna

Cadmium yellow

This painting was taken through several stages, beginning with the initial sketch. As well as increasing both the number and variety of colours used, I also increased the number of brushes to two. A No. 9 was used to wash in the background while I found a No. 3 more suitable for painting around the barrel and its wheels.

To complete the painting I used an artist's trick. When the paper was thoroughly dry, I used the point of a sharp knife to scratch a few marks into the foreground. This created broken lines where the layers of paint were removed, giving the effect of light shining through tiny gaps and falling on to the ground.

Highlights created where sunlight caught the leaves

Shadows created by dabs of green darkened with brown and blue

The leaves appear to have a shimmering effect because they are offset by the darker roof

The texture of the building was created by blotting. The tiny dots of colour that form the shadows were applied with the tip of a No. 3 brush on to a dry surface

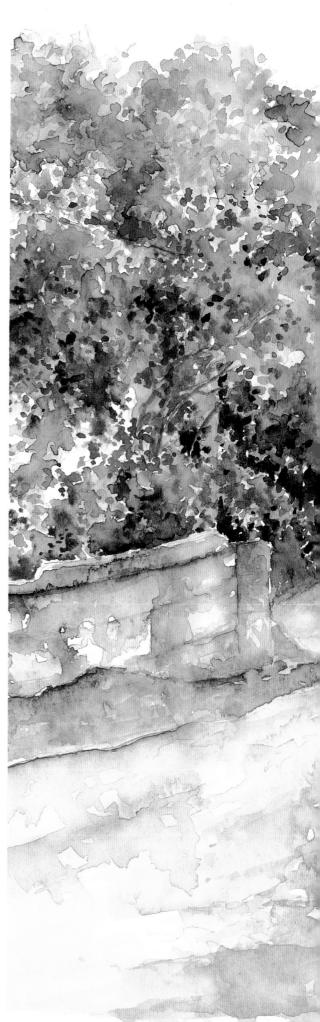

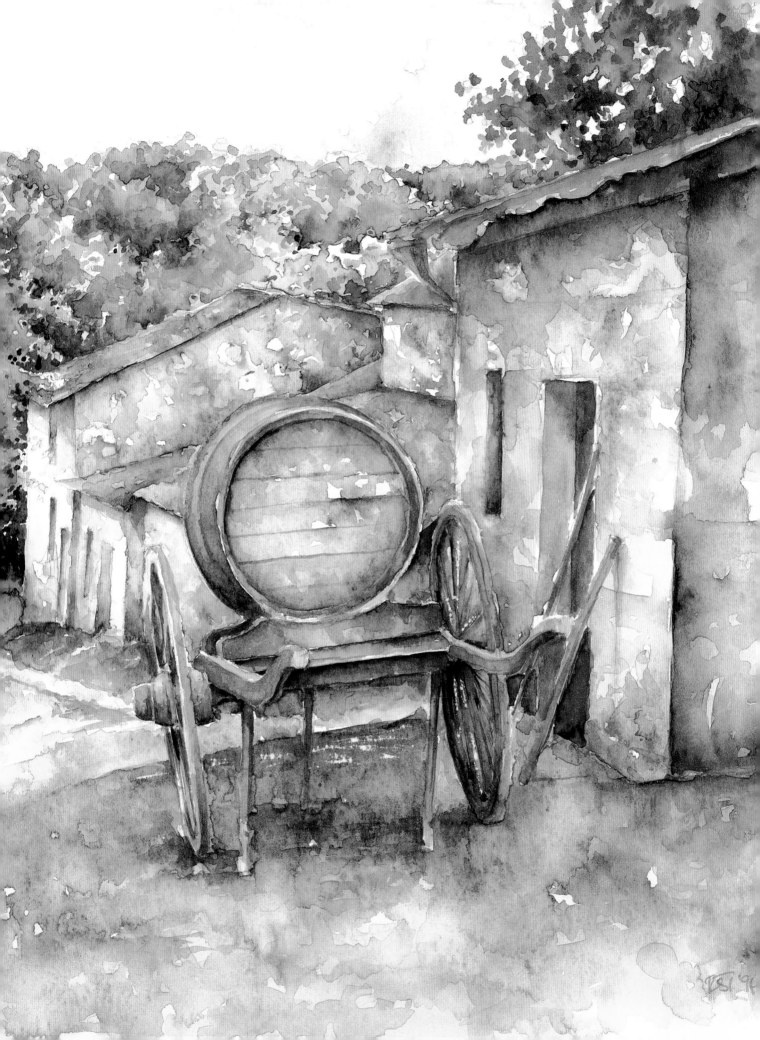

Hints and Tips

- Do not be dictated to by conventional labels – it is possible to use warm and cold colours side by side to good effect.

- When quite detailed objects are required in the foreground of your picture, you may well need to use a smaller brush to pick them out, almost using it as a pencil to draw with.

- Most landscapes require light tones for the background and for the features in the background such as trees and hills. The right effect can usually be achieved by using thinner versions of the foreground colours, or simply by leaving the underwash to form the tones in the far distance.

- Shadows on buildings usually cover a larger area than shadows on trees and therefore they need slightly different treatment. A single wash of the tone chosen for the shadows may suffice, but to achieve any form of graduated shading, one or two more washes may be required.

- Shadows from strong, harsh light will often appear as 'blocks' with rather abrupt, hard edges.

- Shadows created by soft lighting will usually be diffused and will fade out towards their edges. This effect can be achieved by blotting the edges with kitchen roll.

- You do not have to paint the outer edges of your sheet of paper. Why not leave a 'margin' where you can test your colour mixes – you can always cut this off at a later date.

- Dabbing a crumpled piece of kitchen roll on to damp paper allows you to create a rough texture like that found on old or stone buildings. Successive treatments of washing and blotting can build up a wealth of tones due to the translucent qualities of watercolour paints.

- A sharp point can be useful for scratching through layers of paint to reveal the paper underneath. This is a particularly useful technique when you want to give the impression that light is filtering through foliage. Make sure that you only use it on paper that is completely dry though otherwise the paint will smudge and the paper will tear.

Colour Palette for Project 2

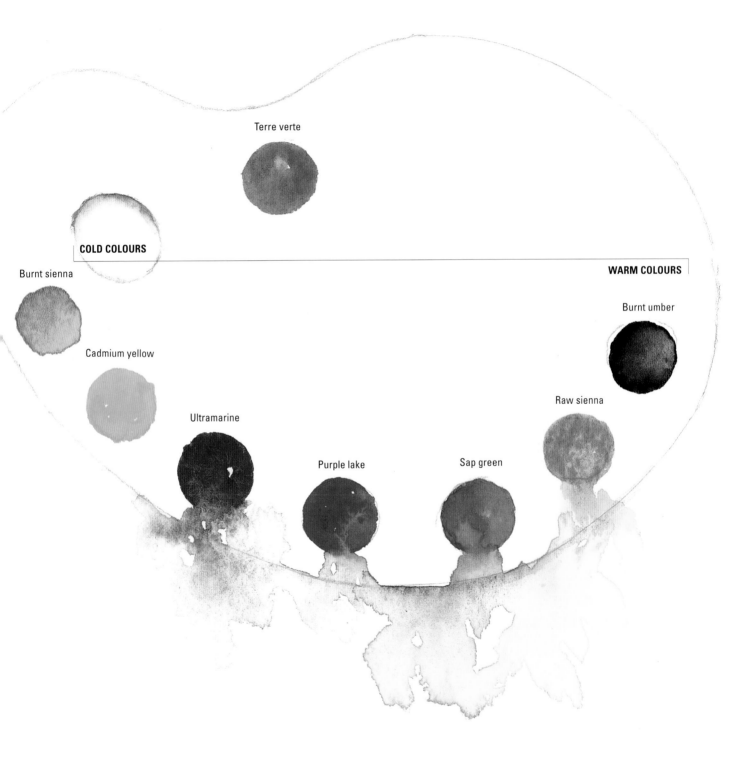

Terre verte

COLD COLOURS

Burnt sienna

WARM COLOURS

Burnt umber

Cadmium yellow

Raw sienna

Ultramarine

Purple lake

Sap green

Finding Colour

Colour surrounds us everywhere we look. Whether in the depths of a snowclad forest or looking out across a rainswept moor or a sunbleached desert you will observe both rich, vibrant colours and more subtle, delicate shades. As an artist, you will also notice important contrasts between light and dark and wonder at just how many variations of a particular colour you can detect. As this book progresses, the idea of building up coloured shadows (both warm and cold) will be considered.

This chapter is primarily concerned with finding colour, which, essentially, means looking carefully at the landscape, not just as an entire scene (although this is important), but at all the individual features of which it is composed. Small clusters of wild flowers for example can add a spark of vitality to an otherwise monotonous landscape and will affect the other colours you select. A shadow cast by a cloud across an open field will also influence your choice of colours.

It is very important to be receptive to colour and to look for it in what may seem to be slightly unusual places. What at first appears to be a jumble of bracken on a forest floor, for instance, may well feature a wealth of colours including a variety of subtly different reds, oranges, yellows, browns and greens all within a square metre. Both the changing seasons and the weather will produce different lighting effects, revealing slightly different aspects of a scene and, most importantly, will show it dressed in many colours. There is great enjoyment to be found in watching the seasons change and in finding the most appropriate colours for each one.

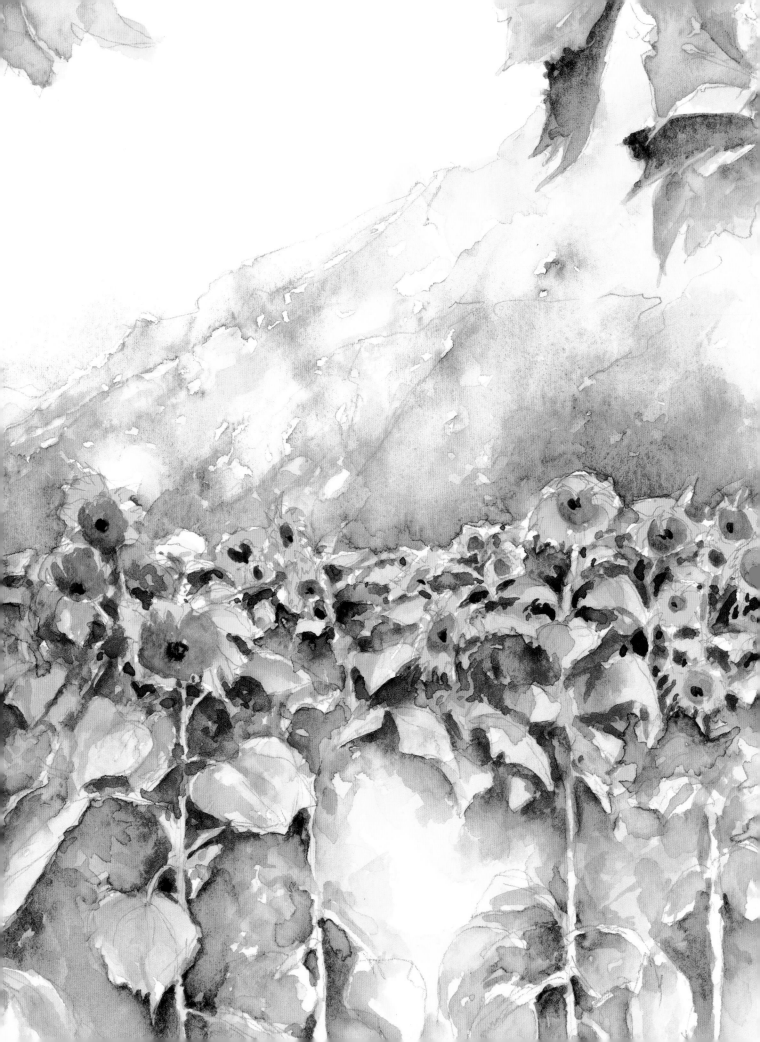

Project 3 **Ground Colour**

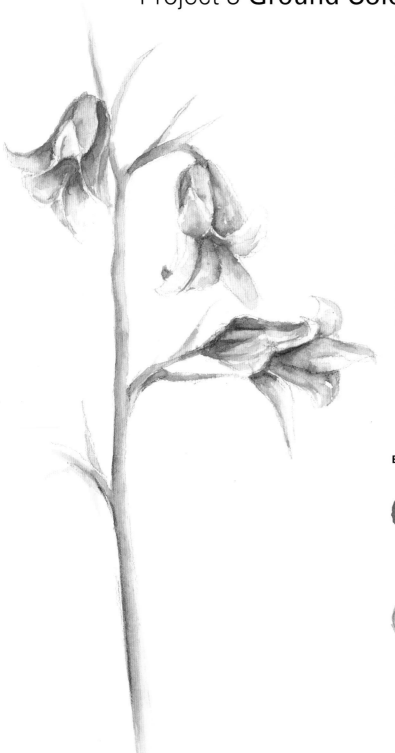

In some scenes it is the sky above your normal line of vision that is the chief source of colour, while in others colour is most apparent in the trees and foliage immediately within your line of sight or on the ground at your feet. Nature is able to provide the purest and most attractive colours, blending them with a delicate touch here and throwing them together in an astonishing clash there. The blue-purple of bluebells and the warm yellow of flowers growing wild in a field are just two examples taken from nature's palette. Establishing the exact nature of these colours required close observation and

Bluebell colours

Ultramarine

Purple lake

careful paint mixing. Having studied them closely, I sketched the two flowers shown here, very quickly recording their main characteristics for future reference in a country landscape picture. I chose paints with the warmest qualities. These were a combination of ultramarine and purple lake for the bluebells and cadmium yellow and raw sienna for the wild field flowers. I placed the two stems side by side so that I could achieve a similar balance in tone. This meant that although I would be using totally different colours for each, the flowers would be consistent in terms of tone, i.e. not too dark or too light.

Meadow flower colours

Cadmium yellow

Raw sienna

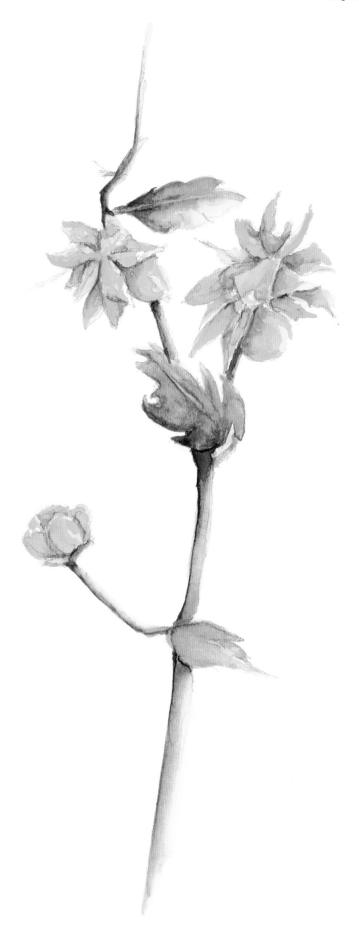

This scene provided an absolutely perfect vehicle for the more expressive qualities of watercolour paints, with the sea of bluebells shimmering in the still, warm morning light.

Visually, the most striking aspect of this scene was the vast amount of blue which could be seen in the sky, in the trees in the far distance (background), in the carpet of wild flowers and in the dappled shadows that fell across the tree.

My choice of blue for the underwash of this on-site sketch was ultramarine. Its warmth would filter through successive layers of paint, underpinning the entire scene. The furthest edge of the field in the background was created by using only the palest of ultramarine washes while the foreground was treated to a more intense application. Then, while the foreground was still wet, a watery mixture of purple lake was dripped on to the ultramarine paint and left to bleed freely.

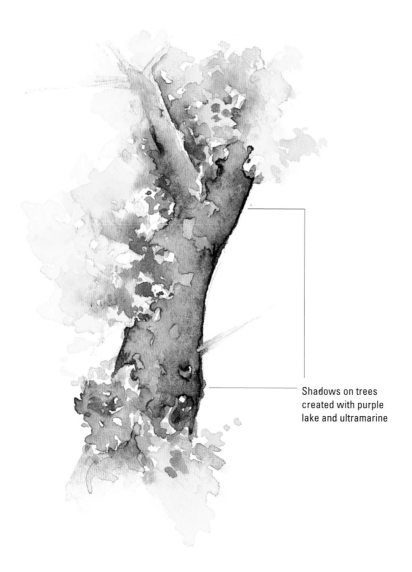

Shadows on trees created with purple lake and ultramarine

This technique of painting wet into wet as described in the previous project is used to create patches of colour that are not bound by harsh outlines and it was ideal in this particular case for capturing the complex pattern of light and shade that appeared in this field. The natural balance between the wild yellow flowers and the blue-purple ground cover was recorded in exactly the same way – while the foreground paint was still wet, cadmium yellow was dripped on to the areas where clumps of yellow flowers appeared. As the paints bled and merged, the impression of a flowing carpet of flowers really began to take shape.

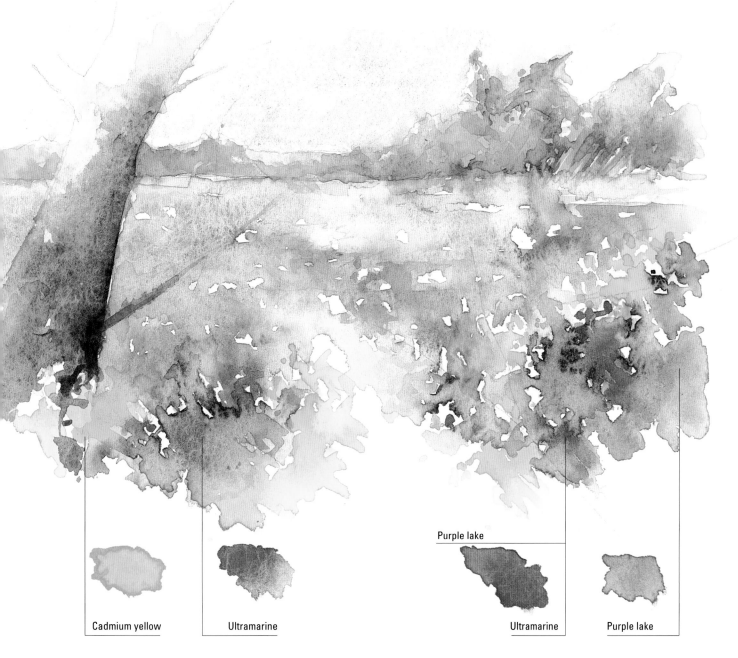

Cadmium yellow

Ultramarine

Purple lake

Ultramarine

Purple lake

Foregrounds

One of the most difficult decisions an artist has to make is when to finish a painting. In this case, I left the foliage and flowers at the bottom of the scene with a very soft and hazy edge. I decided to blot the vertical colour runs in some places but allowed the colour to run and bleed freely in others. This gives the picture the kind of fairly loose and relaxed style to which I believe watercolours are best suited. It also frees you from feeling that you have to paint a border.

The flower shapes in the foreground of this scene almost seem to take on an abstract form. This style is sometimes preferable to detailed and very realistic photographic-style representation. The results that can be achieved by dropping a small amount of paint on to wet or damp paper and leaving it to spread so that it takes on a wonderful variety of forms and shapes illustrates the beauty and simplicity of watercolour.

You need not be restricted by the idea of having a rectangular border. Allow the paint to bleed and flow, finding its own way as it has along the bottom edge of this picture.

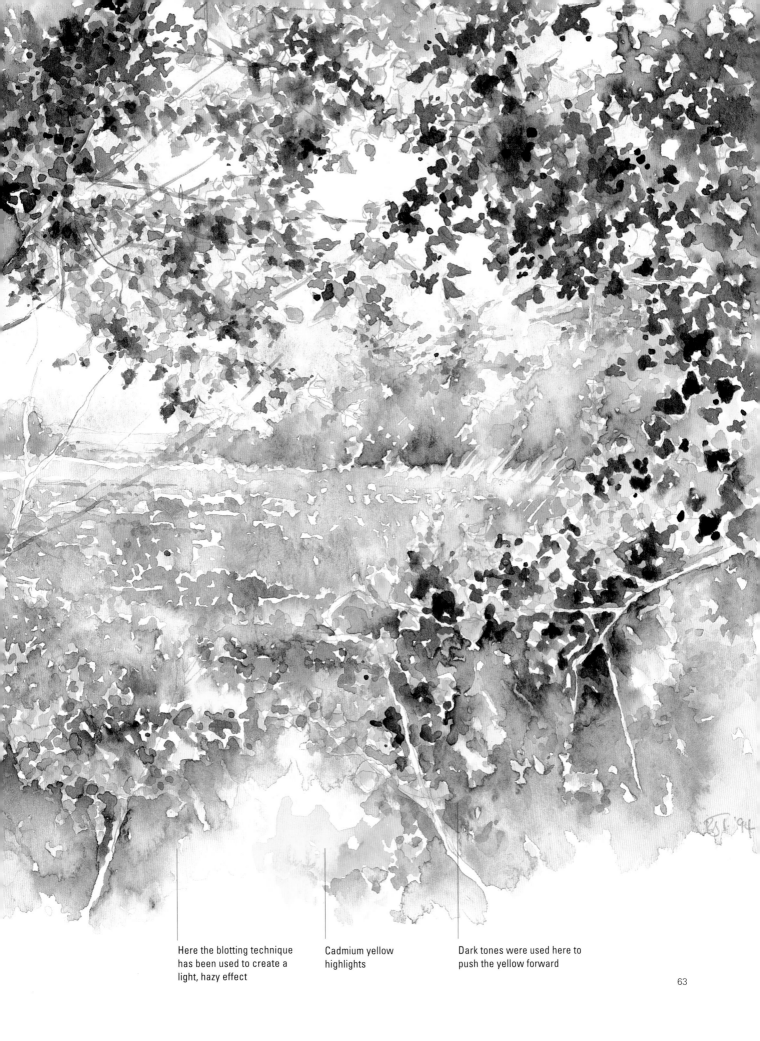

Here the blotting technique has been used to create a light, hazy effect

Cadmium yellow highlights

Dark tones were used here to push the yellow forward

Hints and Tips

- Underwashing a painting establishes the tone of the scene. Ultramarine, for example, is particularly well suited to warm landscapes.

- Painting wet into wet is perhaps the best method to use when creating fields and natural carpets of colour as well as textures on buildings. Remember that you will need to work quickly though, before the first application of paint has started to dry.

- Don't be afraid to let paint flow and bleed. You can always control it by blotting if it does not move in a way that you are happy with. Sometimes the shapes that occur can work to your advantage simply by representing parts of a scene that may well take hours to paint in detail otherwise.

- You need not always paint right to the border of your paper if you feel that a scene would be more balanced or more appealing by fading out towards a corner or an edge or by letting the paint bleed or run out of the composition. This is always a matter for the individual.

- Try to maintain consistency of tone for similar objects even though they may not be of the same colour. Any two wild flowers, for example, which appear in the foreground of a scene may be totally different colours, but their proximity to each other will mean that they will probably be of a similar tonal value – neither darker nor lighter in tone than each other.

- You can make light objects stand out by darkening the colours immediately behind them. This is often referred to as the 'push-pull' effect.

- Look to the sky for the dominant colours of the day. Establishing these will help you to make choices about colour and tone.

- Choose some small examples – such as flowers, grasses or leaves – of the objects that make up the key colours of the scene for sketchbook studies, placing them side by side to ensure consistency of tone.

- Watercolour painting does not always require brush strokes. Sometimes a drip of colour from a loaded brush on to wet paper can create an interesting shape as the paint dries.

Colour Palette for Project 3

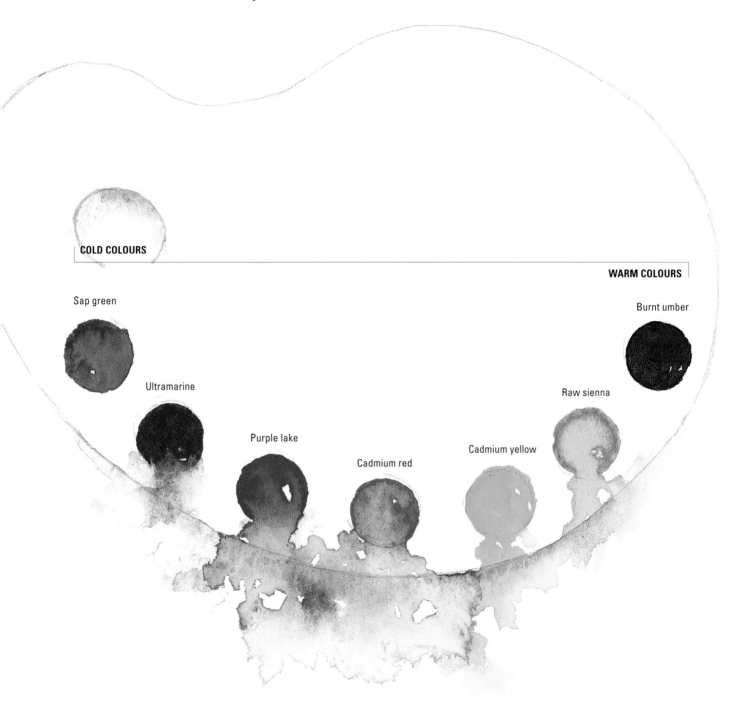

COLD COLOURS

WARM COLOURS

Sap green

Burnt umber

Ultramarine

Raw sienna

Purple lake

Cadmium yellow

Cadmium red

Project 4 **Coloured Trees**

One of the advantages of being a landscape painter is the freedom you have to choose and use colour. Sometimes nature will present you with something unusual or unexpected, affording you the opportunity to achieve stunning effects just by putting particular colours together. The previous project illustrated a scene awash with blue and purple tones. By complete contrast, in this picture oranges and reds flooded the scene, with one brightly-coloured tree looking almost as if it was about to be engulfed in flames.

I chose the equipment for this painting carefully, knowing that a fair amount of water would need to be applied to achieve the colour runs and bleeds. Firstly, a sheet of good strong paper and a No. 9 brush were required. A heavy wash made up of a combination of sap green, burnt sienna and cadmium yellow was prepared and applied to pre-dampened paper. As this wash was drying, I blotted out a few areas which I intended to highlight. Rather than simply dabbing the paint with a ball of kitchen paper, however, I decided to introduce a new technique this time. I folded a small piece of kitchen paper several times until I had formed a kind of blunt knife edge. I then pulled this down along the lines of the tree trunks and branches, removing the paint and forming a number of negative images.

The other interesting consideration in this scene was that the reds and oranges of the foliage were to some extent reflected on the stonework of the bridge. I applied a wash, made from a combination of the colours on my palette that I had used for the trees, to the bridge to give it some warmth and a mellow appearance. This helped to make it blend harmoniously with its natural surroundings.

The idea of colours being picked up or reflected by their surroundings warrants a little attention here. I do not clean my palette when painting. Once I have mixed up a set of colours – in this particular case the various reds, yellows and oranges of the spectacular foliage – I do not attempt to remove all trace of them before mixing up another set of colours. This is because all the objects in any one scene are touched by the same light although it may not be obvious instantly. So, to ensure continuity of tone, make sure that you do not use colours in total isolation. Any landscape, however vibrant or luminous, will contain its fair share of muddy or neutral background colours, and these are best created out of all the other colours chosen for the scene mixed together on your palette. The most dominant colour will show through, as is the case on the bridge and road featured here. This is rather similar to what happens at sunset, when the colours that the light from the setting sun creates touch everything in their path. Trees, houses and rocks all take on a red-pink tone as they are bathed in the sun's last rays. You will see that even in normal daylight a similar effect is created, although it is much more subtle, and it is important to capture the essence of it in your paintings.

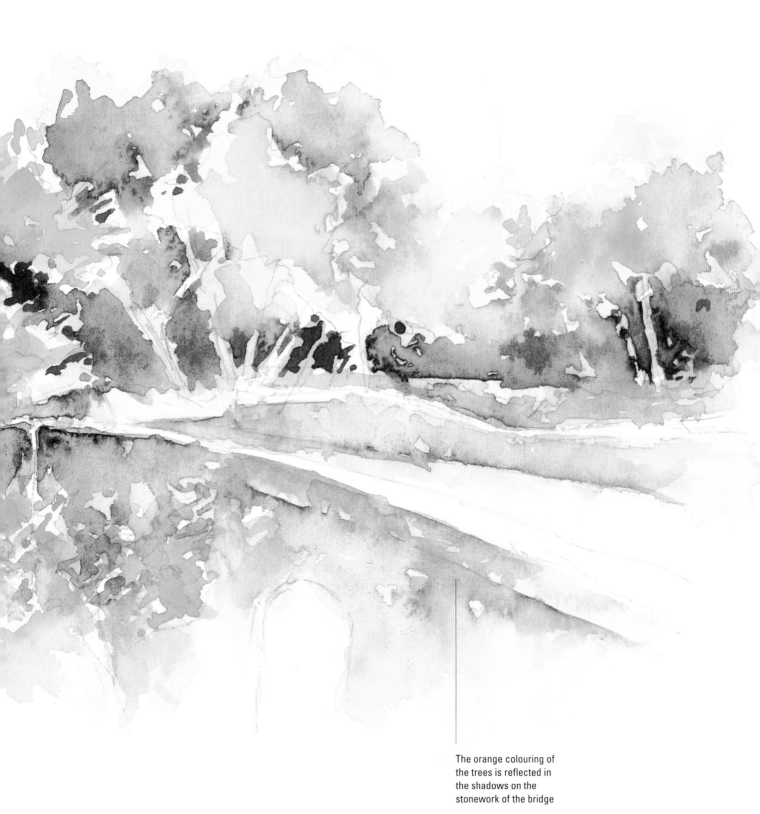

The orange colouring of
the trees is reflected in
the shadows on the
stonework of the bridge

Having formed the basic tree shapes by applying a colour wash and blotting where appropriate, it was time to enhance the intensity of the colours that were the key to the scene.

In order to achieve this, the background area was treated to a very watery second wash of greens and warm earth colours including burnt sienna and raw sienna. Before allowing this to dry, the main tree in the foreground was treated to a richer wash of cadmium red and burnt sienna. This created a gradual, flowing build-up of colour. As this was drying, yet another wash of yellows and green was added to the edges and left to bleed inwards. Then a few drops of cadmium red were dripped into the very centre of the main tree and allowed to bleed freely. The outline of the tree had been established by the initial blotting process so the paint was allowed to find its own way and create its own shapes within those limits.

The bright colour is intensified against a dark background

Dark shadows push the bright orange-red colour forward

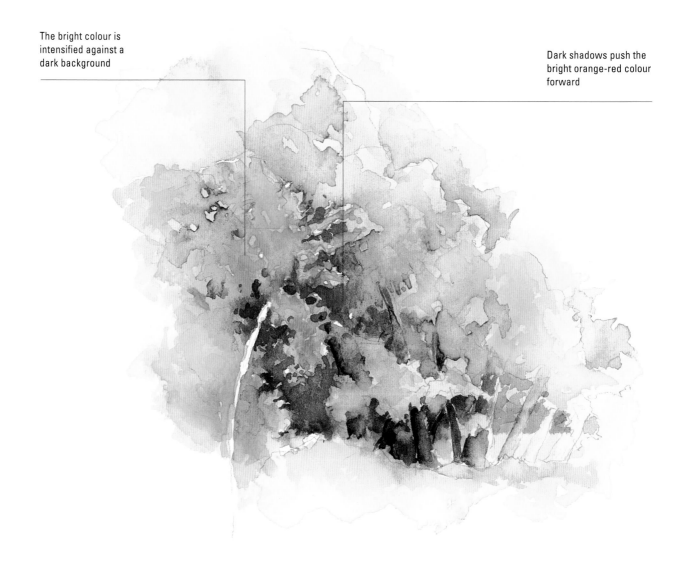

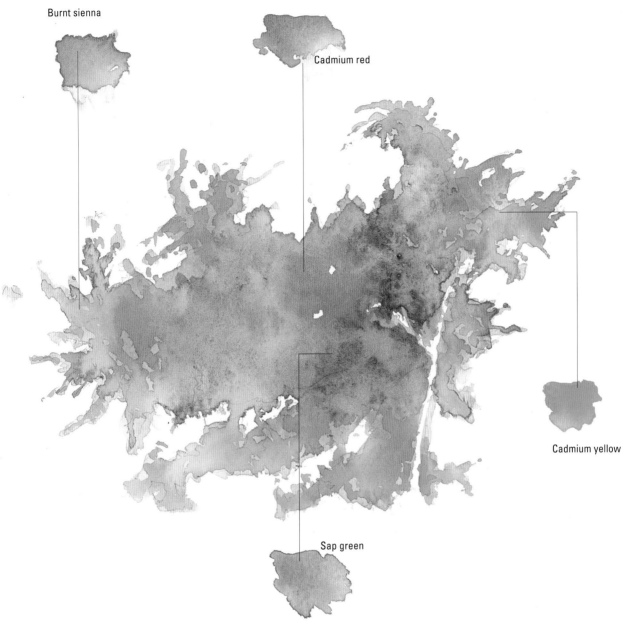

Burnt sienna

Cadmium red

Cadmium yellow

Sap green

The technique of washing, bleeding and blotting is one that I use frequently in my sketches and paintings. The project on page 62, where a subtle blend of yellows, mauves and purples was required to create a carpet of wild flowers, considers this technique. In this particular scene, the same technique was used but this time, however, the main aim was to produce some visually dynamic contrasts using the full strength of the reds and yellows. As with almost every aspect of watercolour painting, there are no rules to dictate exactly how much water to use or how many times you can apply successive washes to a sheet of paper before you risk creating a dull, muddy wash or before your paper starts to cockle. You will learn to judge these matters for yourself by experimenting. As your level of skill increases you will develop a unique style of painting which will be in keeping with your personal taste whether it is for free, watery washes or for fine, delicate detail.

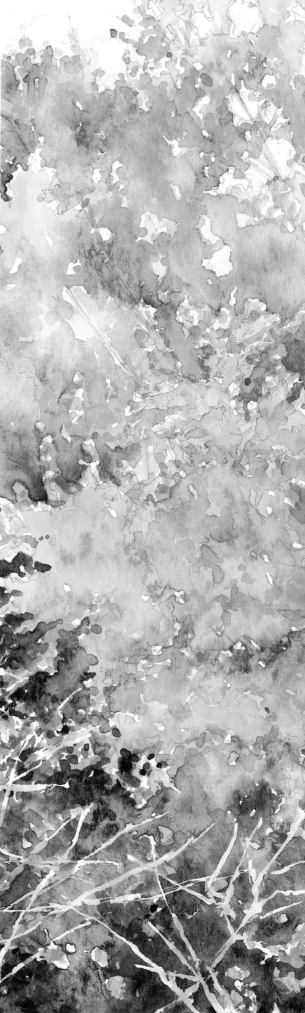

The final picture appeared to be a fairly complex mixture of watery bleeds and positive and negative images although it was actually achieved quite simply. Some of the tree trunks were painted in lighter shades than the background while others were left bare to stand out against the intense colour of the foliage.

The negative branches at the bottom of this scene were created by careful painting around their outlines in the final stages. A little dark paint was applied to the dry paper with a fine brush, allowing for total control of the paint with no bleeding or running occurring.

The first thin wash of paint

Red paint dripped on to the first wash

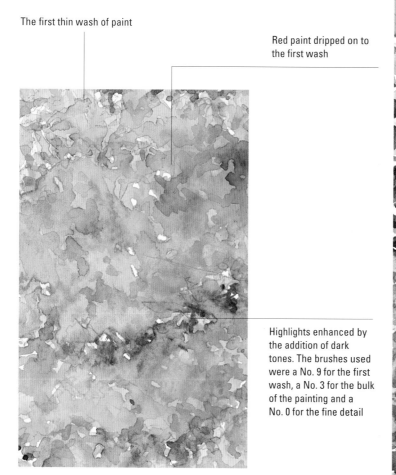

Highlights enhanced by the addition of dark tones. The brushes used were a No. 9 for the first wash, a No. 3 for the bulk of the painting and a No. 0 for the fine detail

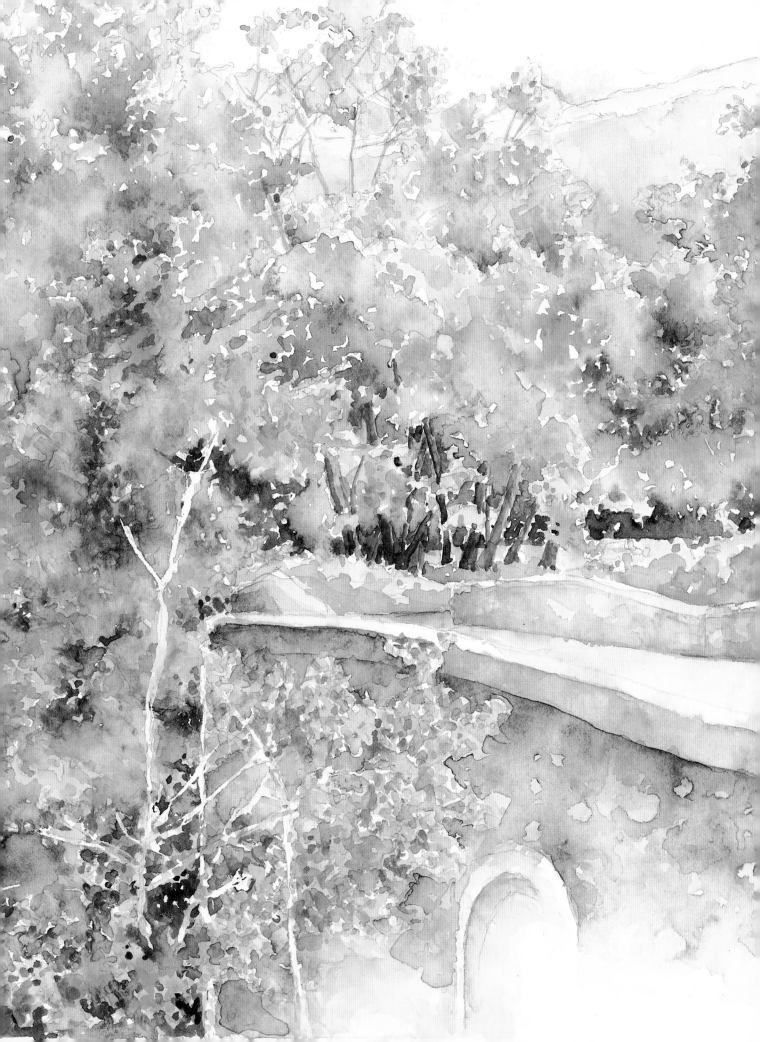

Hints and Tips

- Choose a good strong paper if you are going to build up a succession of watery washes. You can flood strong paper without the risk of it cockling. It should retain its flatness as you work.

- Always choose a big brush for covering large areas of paper – this increases the speed with which you can cover a sheet of paper. It also helps to eliminate brush strokes and watermarks appearing on the underwash.

- Negative images can be formed by blotting with the edge of a piece of folded kitchen roll.

- Watercolour paint, by its very nature, flows freely and easily given the chance. Sometimes this can work to your advantage. If you blot around the shape of a bush or tree, just leaving the centre damp, you can drop paint on to the middle and it will bleed along the path of the water. It will stop at the dry area which acts as a boundary for the bleed. You can control this, if you wish, by blotting, but you may not wish to interfere.

- Paint will usually bleed downwards towards the bottom of your paper because you will tend to incline the base of the paper towards yourself as you work on a picture. You can always turn your paper upside down, or incline it away from you, if you want the paint to bleed up towards the sky.

- The colours you select for the main feature of a scene, such as a bridge or a tree in the foreground, will dictate the range of paints you use for all the other parts of the picture.

- Drag the edge of a folded piece of kitchen roll across selected areas of your sheet of paper. The kitchen roll will absorb the damp paint, creating negative shapes such as the lines of branches.

- When you apply wet paint on to dry paint, a watermark can occur around the patch of new paint as it dries. This can sometimes have a positive effect on your composition. If, however, you want to prevent the mark from occurring, gently blot the edge of it as you see it developing.

Colour Palette for Project 4

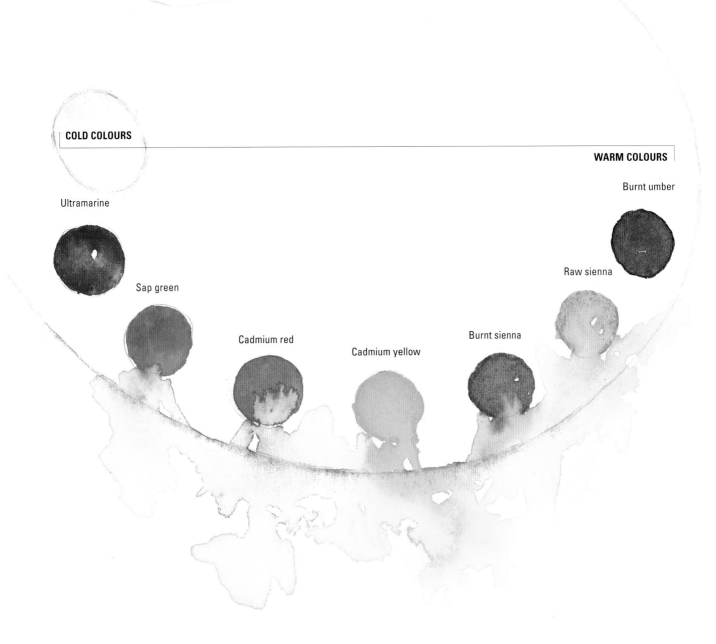

COLD COLOURS

WARM COLOURS

Burnt umber

Ultramarine

Sap green

Raw sienna

Cadmium red

Burnt sienna

Cadmium yellow

Warm Landscapes

Landscape painters usually tend to associate different colours with different temperatures and moods of the day. Colours such as purple lake as well as siennas and umbers are most often used to capture the mood of a warm landscape. Remember that bright or sunlit landscapes are not always warm – in fact they might well be bathed in a cool blue light. A number of different factors such as mellow golden light, blends of yellows, reds and purples and old or weathered stonework combine to make up a warm landscape. Warm colours can be used to give shadows that can be seen in the foreground of many landscapes on both natural and man-made objects the right appearance. Throughout this chapter, I will be dealing with warm landscapes and choosing the most appropriate colours for them.

As mentioned in the introductory pages, it is not possible to find exact matches for naturally occurring colours in paint tubes, but rather than this being a hindrance, it gives us the opportunity to develop our own versions – sometimes surprisingly accurate and at other times just loose interpretations – which can enhance the mood or atmosphere that the light on the landscape creates. This is part of the pleasure of watercolour painting. We will often use colours that we do not necessarily see, but which we know can give the desired effect. Shadows can be created using a mixture of ultramarine and purple lake, for example, bathing brickwork in a wash of warm gentle light. The tinge of purple contained within the shadow may not have been obvious to the casual observer straight away, but with a little sensitivity, and by practising the techniques covered in this book, you will soon learn how to translate what you see on to paper.

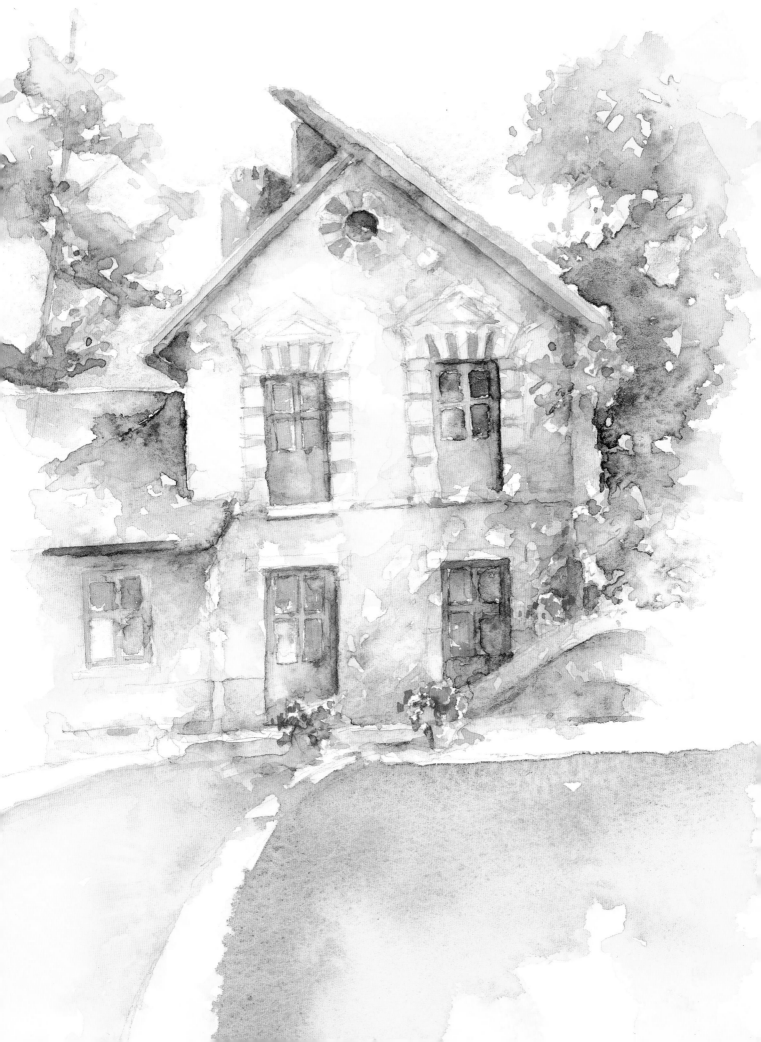

Project 5 **Water and Reflections**

Water can be a very relaxing subject to paint, especially when you come across a tranquil pond or lake. The one important thing to bear in mind from the artist's point of view is that most water moves. The slightest, gentlest breeze creates a series of ripples, breaking the stillness of the surface. Mirror reflections of river banks, trees or houses are, therefore, rare.

Scenes featuring perfect reflections are usually captured by photographers and they are often the result of hours of patient waiting just for a brief moment of stillness. However, this is not really a practical approach for a painter.

One thing that painters and photographers do have in common though, is that they are both concerned with capturing an image or scene and, more often than not, the colours contained within it. For this reason, it is not unusual for painters to make use of photographs to complement their sketchbook studies. Working directly from photographs without the benefit of your own sketches – which will include, for example, firsthand notes, studies of individual leaves, rocks, shells and clouds – can be an unrewarding task. When you

are sitting in front of a landscape you are, in fact, part of it. The light and colour does not just exist in front of you but all around you. You are part of the scene which exists in three dimensions. Should you take a photograph of the scene and attempt to copy it, you will probably end up with an accurate series of shapes, but they will probably be 'flat' shapes in the sense that they will not reflect the effects of distance and atmosphere and the subtle variations in colour that you observed when you were there. In other words, photographs are a very useful tool for the painter but they can never truly replace the special qualities of a few quick notes in a sketchbook.

It is best when approaching the subject of water to think more in terms of colour bleeds than mirror images. The paint can be made to suggest the shapes of trees without you having to attempt to produce exact copies.

As little real detail is required in scenes where water appears in the foreground such as the one seen here, you will only need one brush (No. 3) to wash colour downwards on to the river or pond.

View any pond, lake or river as part of an all-embracing landscape. Water reflects the sky, the trees and all the colours that surround it.

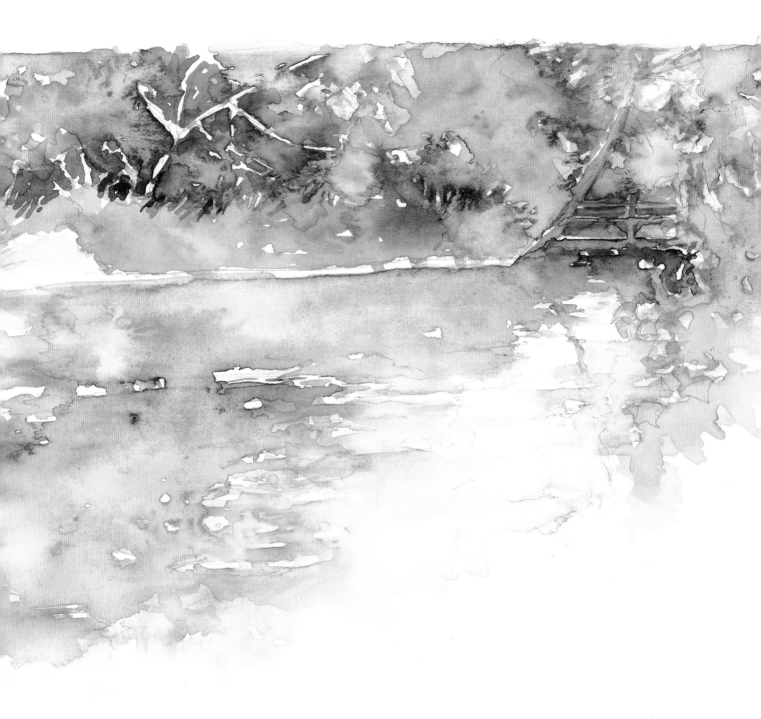

Mirror reflections are rare, and especially so on moving water. Clever application of your colours can produce a good representation of the shapes of trees along the bank reflected in the water without you having to go into painstaking detail.

Step-by-Step Reflections

The first stage of painting reflections on water is to establish a translucent base of colour on which to work. In this case, the basic shapes of the trees were washed on to dry paper first using a mix of sap green and raw sienna. The section of water where the reflection occurred was treated to a very thin, pale wash of ultramarine, and the greens used for the trees were then applied to the wet paper and 'pulled' downwards. You will notice that a narrow line or space was left between the base of the trees and the lake's edge in order to distinguish the bank from the water. This gap is very important in that it acts as a physical barrier, which helps to prevent the painting from turning into one long featureless bleed.

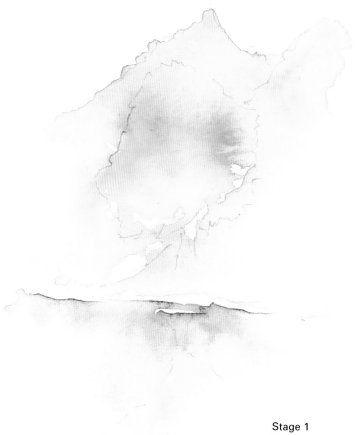

Stage 1
The undercoat was established using a thin wash of sap green and raw sienna for the trees and ultramarine for the water.

The next stage is to develop the colours and shapes of the trees and land further by painting in shadows and darker tones using the same green but mixed with less water. Using a wet brush, a thin wash of these deeper greens and yellows was also pulled downwards quickly so that the shapes of the trees on the bank would be loosely echoed in the water. This was followed by another slightly more intense wash after which the shapes and tones of the tree, the surrounding foliage and the other features of the scene were more clearly defined with a No. 3 brush.

When the paper was completely dry, the technique of scratching the surface of the paper (as described in Project 2 on page 52) was used to create the effect of light catching the ripples.

A medium size brush should be used to pull colours downwards. It is important to maintain the physical break of the bank immediately above the waterline.

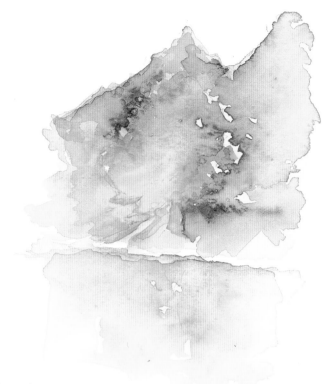

Stage 2
Establish shapes by adding shadows and dark tones.

Stage 3
Pull the tree colours downwards to form reflections in the water.

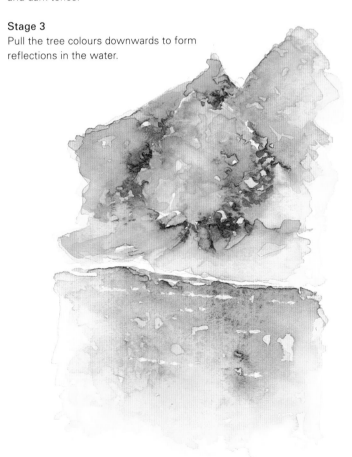

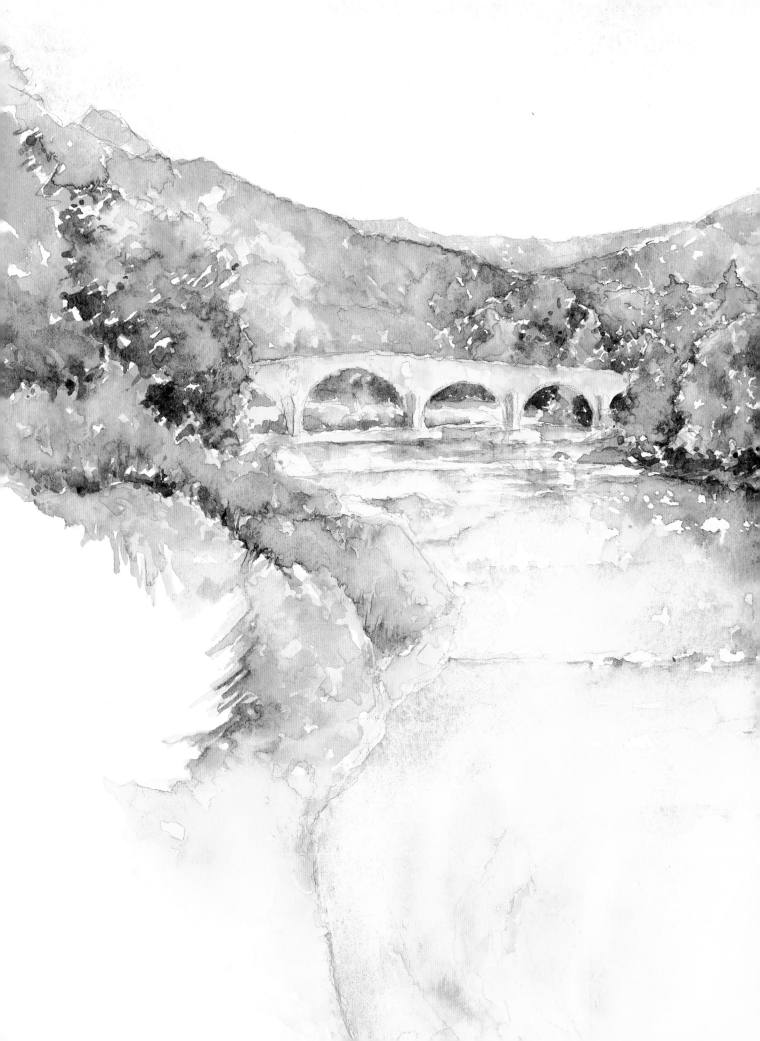

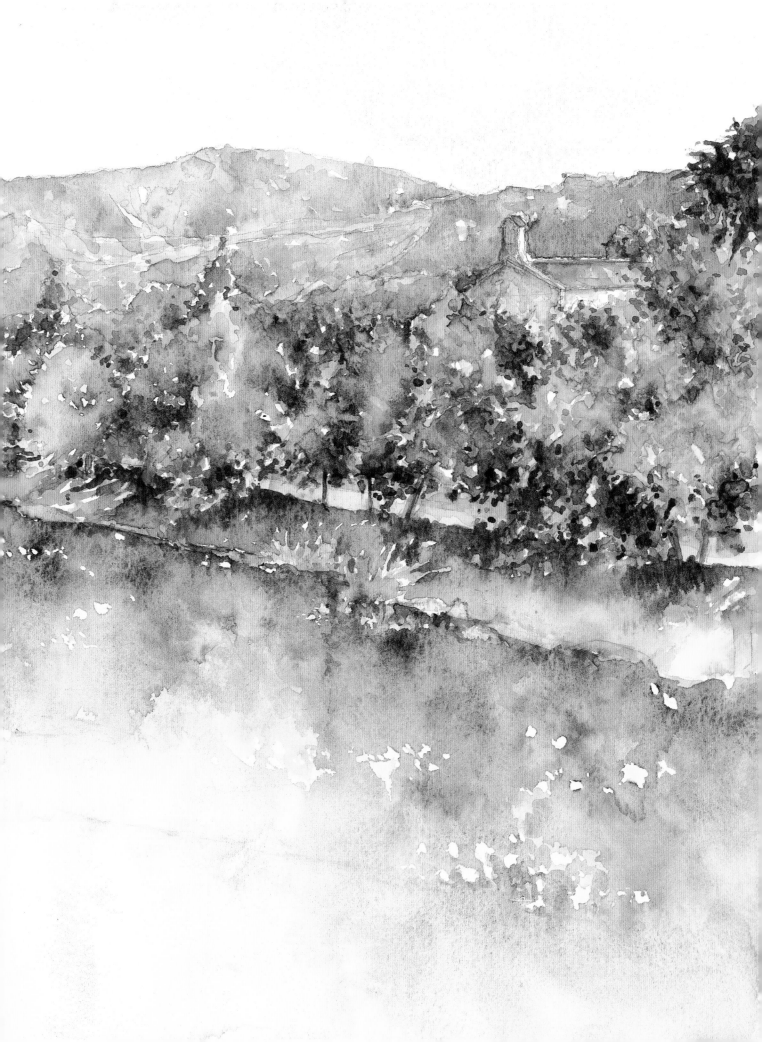

Hints and Tips

- Do not be concerned with the perfect reproduction of reflected images. Creative colour bleeds can be much more rewarding and effective.

- While painters usually mix their paints on a palette and apply them ready mixed, scenes featuring rivers, lakes and ponds can often be painted by applying colours to wet paper and allowing them to bleed (using the water as the medium) and mix freely. It can be fascinating to experiment with this technique and watch the paints flow into attractive shapes.

- Reflected colours will often be diffused or muted. This works to your advantage when painting reflections as dilution and diffusion of colours occurs naturally when you apply paint to wet paper.

- It is advisable from the artist's point of view to leave a definite space between the bank and the water – usually a thin strip of bare white paper. This prevents the bank and the water from appearing as one big wash, helping to define the line of the water's edge more clearly.

- Water scenes and reflections can be painted successfully using one medium size brush because little detail in the foreground is required.

- You may find that you need to blot the reflections to create the right shapes but you can often achieve a wonderful effect simply by pulling your washes down on to your lake, pond or river area and allowing them to bleed.

- The technique of scratching away layers of paint from the surface of your paper with a sharp point can be particularly useful on water as it can create the effect of flickering light reflecting from ripples.

- If you are painting large expanses of water, you will find that the sky forms part of your reflection. Reflected clouds will need a pale wash as water never reflects pure white.

Colour Palette for Project 5

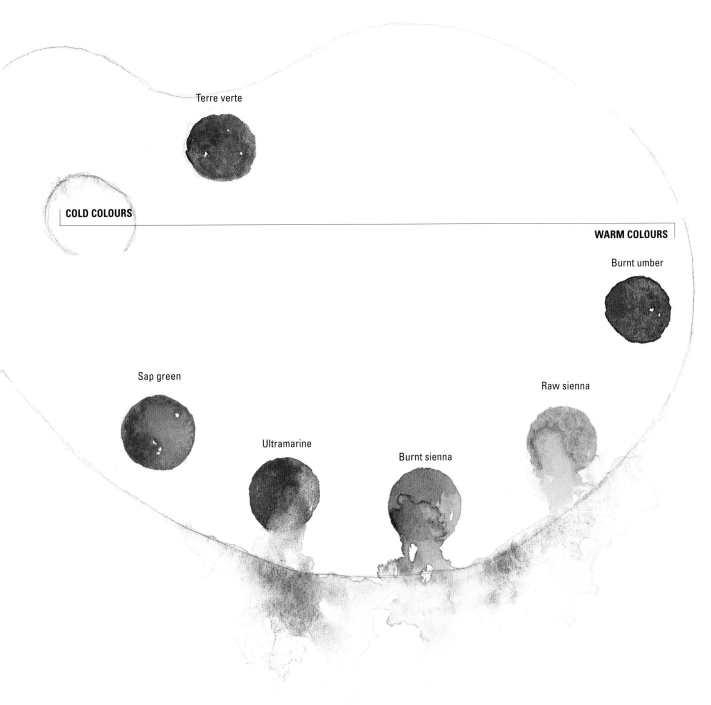

Terre verte

COLD COLOURS

WARM COLOURS

Burnt umber

Sap green

Raw sienna

Ultramarine

Burnt sienna

Project 6 Brambles and Hedgerows

Brambles and hedgerows are a good place to start when planning a country painting. It might at first be difficult to see how a painter could make sense of a patch of undergrowth composed of a concentration of leaves, brambles and twigs such as the one shown opposite, but the wealth of textures and colours actually makes it a very interesting and visually appealing subject. This natural chaos with its medley of lines and shapes would of course be too challenging to record in minute detail. It can be rewarding to paint a much looser and more subjective interpretation of it, however, by laying down washes of colour and selectively blotting and by using the push-pull technique mentioned on page 64, which involves using dark colours and tones to push the lighter ones into the foreground, making them appear to stand out on the paper.

As we can never hope to record absolutely every detail we see in a scene such as this, it is necessary to begin by focusing on either the largest or the most prominent features. You will need to observe them carefully before starting to paint as getting these right will be the key to the success of the whole composition. The important elements in this case were a few large red leaves and some branches and twigs. The background was first treated to an earthy wash of sap green, burnt umber and raw sienna. Selected areas were then blotted carefully to suggest shady leaf shapes. Some darker patches made up of a more intense version of the first wash were painted on to the damp paper behind these shapes and were left to bleed freely. This enhanced the leaf shapes, making them seem caught by stray shafts of light filtering through the brambles.

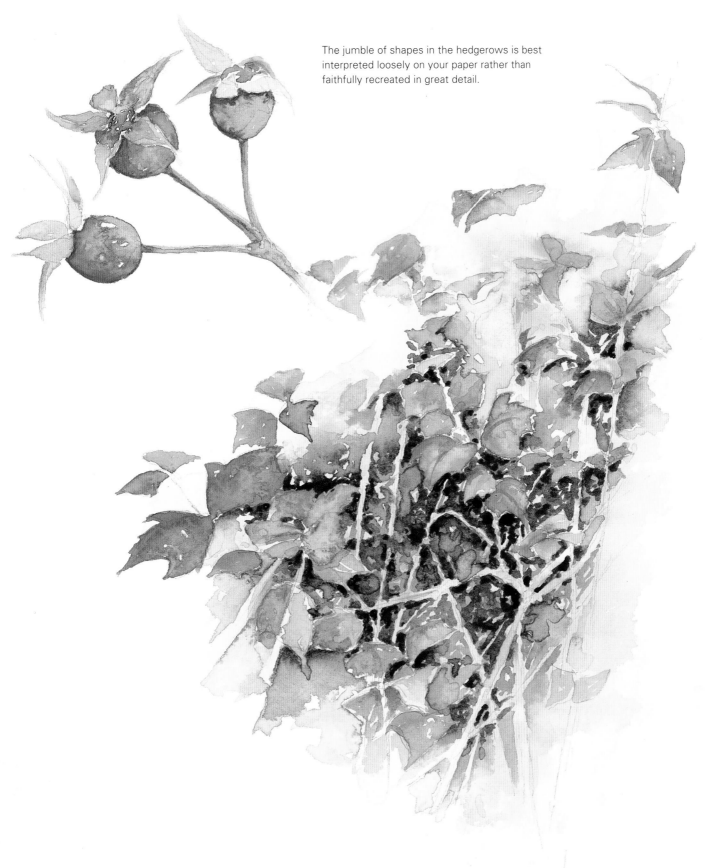

The jumble of shapes in the hedgerows is best interpreted loosely on your paper rather than faithfully recreated in great detail.

Painting Foliage

The illustration shown opposite charts the successive stages of painting foliage simply but effectively. Initially, the key leaves were drawn, following the line of the branch to which they were attached. I selected and mixed colours for the leaves that would reflect the warmth of the sun and washed them across the whole area. This particular technique will soon come naturally to you as you become more familiar with mixing colours and applying them as light washes. While this paint was still damp, a slightly darker mixture, which was enhanced by the addition of a little more burnt umber was introduced around the edges of the leaves. When the paper was dry, I took a No. 0 brush and used the point to paint on the central veins to make the leaves look more realistic.

I used burnt sienna, sap green, burnt umber and raw sienna. These colours were in keeping with the soft, muted, earthy colours of the season.

You may observe pale leaves standing out against a dark background and darker leaves offset by a light background – positive and negative images. It is helpful to try to capture these contrasts in your painting. Here you can see how to record a group of leaves successfully using both positive and negative painting techniques.

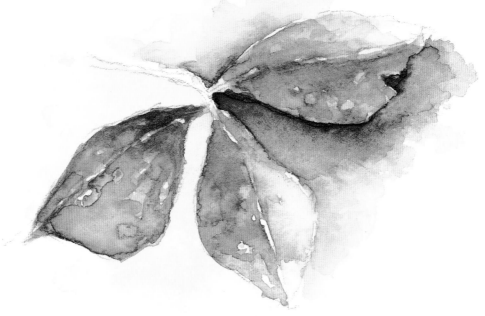

A range of warm natural earth colours was used to capture the subtle shades of green and brown in this group of leaves. The colours gradually blend into one another, fading out towards the edges of the sketch.

Burnt sienna

Sap green

Burnt umber

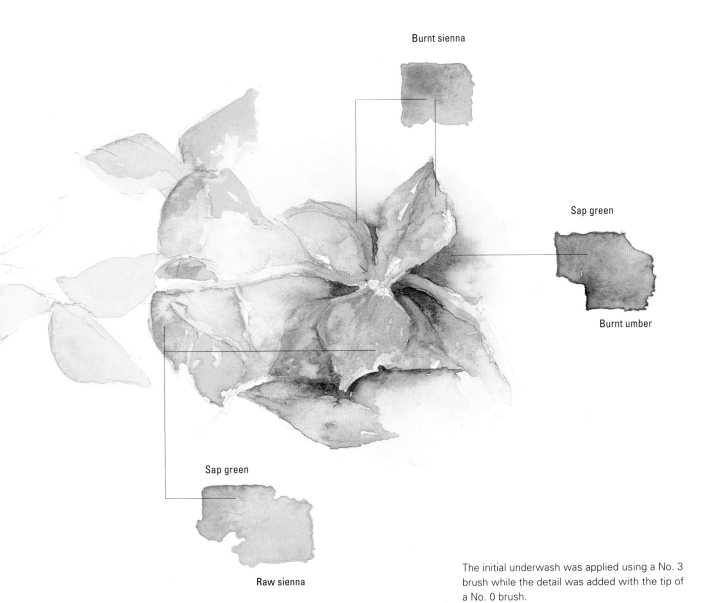

Sap green

Raw sienna

The initial underwash was applied using a No. 3 brush while the detail was added with the tip of a No. 0 brush.

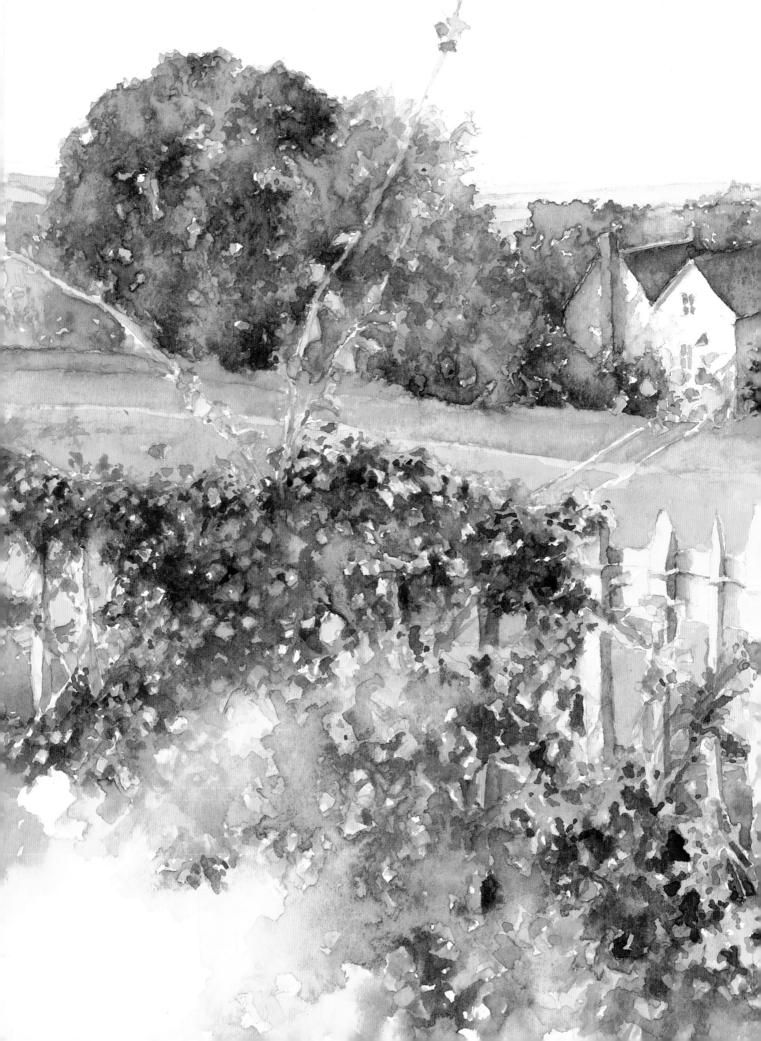

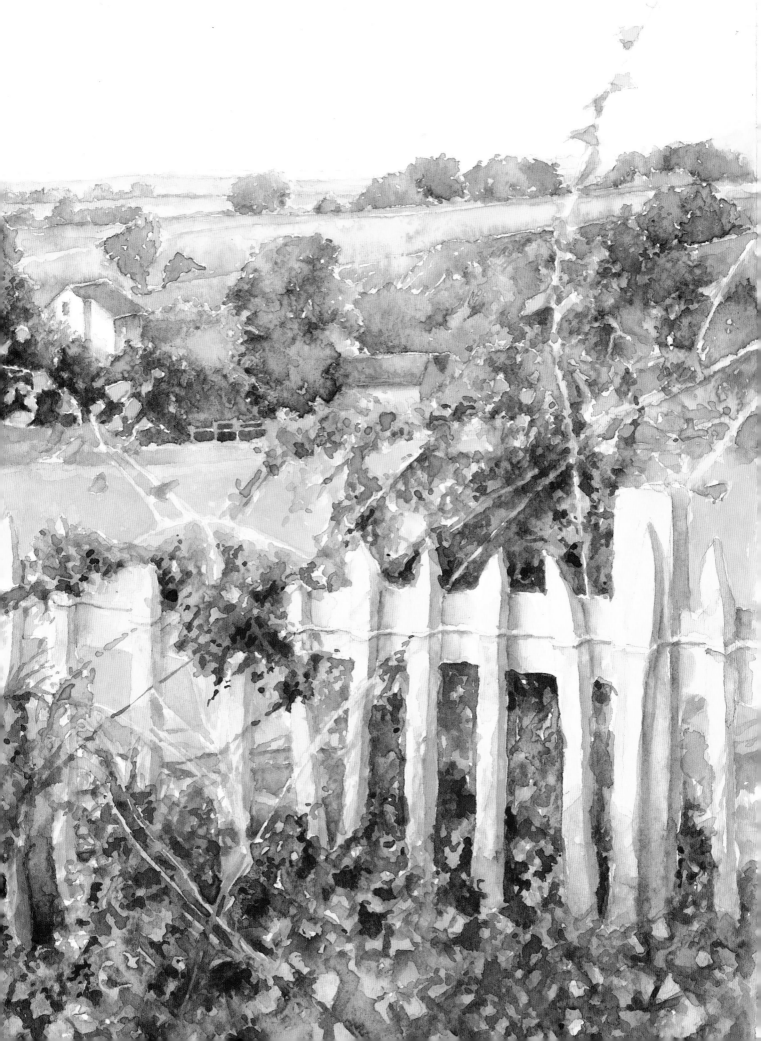

Hints and Tips

- It is not a realistic aim to attempt to record everything to be found in brambles and hedgerows in painstaking detail. It is better to focus on the main features and to suggest everything else through clever use of colour and texture.

- The complex nature of undergrowth and hedgerows requires close observation of colour, so use your sketchbook before you begin in earnest. Make notes on all the individual objects you can pick up including berries and twigs. Jot down also the colours you choose from your palette to record them.

- If you do choose to attempt quite a detailed composition, it can be a good idea to select a smoother type of paper which will allow you to draw and paint clean uninterrupted lines.

- Negative shapes can often be introduced with good effect when painting hedgerows. Light branches tend to stand out against the darker tones of the undergrowth, bringing contrast and definition to your composition.

- Large or colourful leaves as well as cones, acorns or bright berries make attractive subjects to paint and concentrating on a group of these will help you to make sense of a confused scene.

- The first pencil sketch you make does not need to be the only time you use a pencil. You can always use one to sharpen or define a few key leaves, brambles or berries while working on a painting.

- Allow the fluidity of watercolour paint to create the illusion of shadowy shapes. Soften outlines and edges by blotting wherever you consider it appropriate, especially in between the key leaves you have picked out.

- Burnt umber and burnt sienna are very good base colours to use when painting the warm glow of hedgerows during the later months of the year.

Colour Palette for Project 6

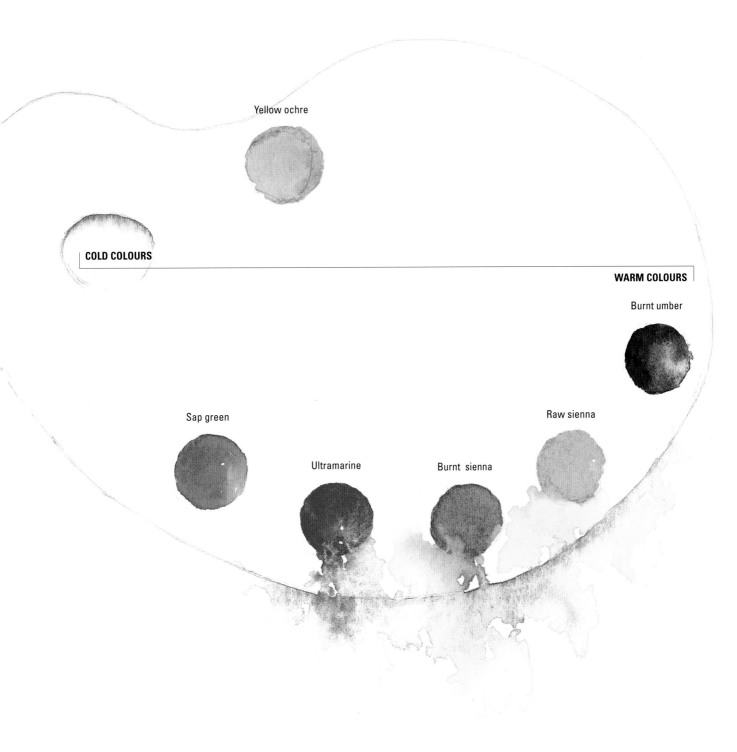

Yellow ochre

COLD COLOURS

WARM COLOURS

Burnt umber

Sap green

Raw sienna

Ultramarine

Burnt sienna

Project 7 **Woodland Scene**

The woodland scene shown opposite was aglow with colour as it lay bathed in the warm, late afternoon light. The sun caught the sides of the tree trunks, and flickered and played gently upon the red and orange leaves. I referred to colour studies I had worked on previously (see below and page 9) when selecting my paints. The rays of sunshine that filtered through the foliage into this clearing seemed unusually strong and they created pools of bright, golden light, contrasting with and exaggerating the patches of shadow on the tree trunks. I gave very careful consideration to the colours I would need for these shadows.

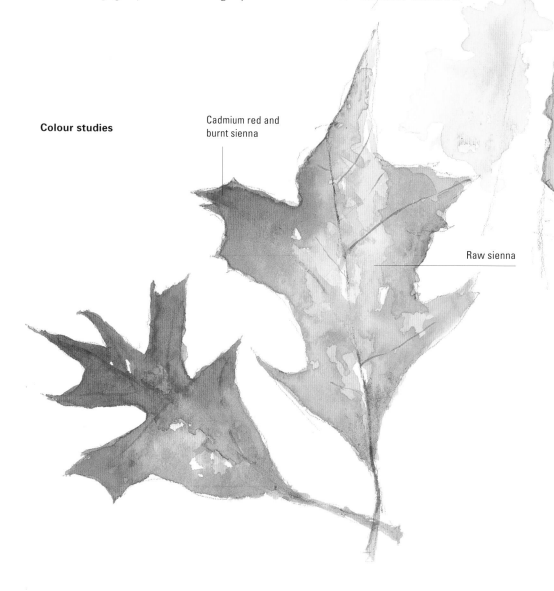

Colour studies

Cadmium red and
burnt sienna

Raw sienna

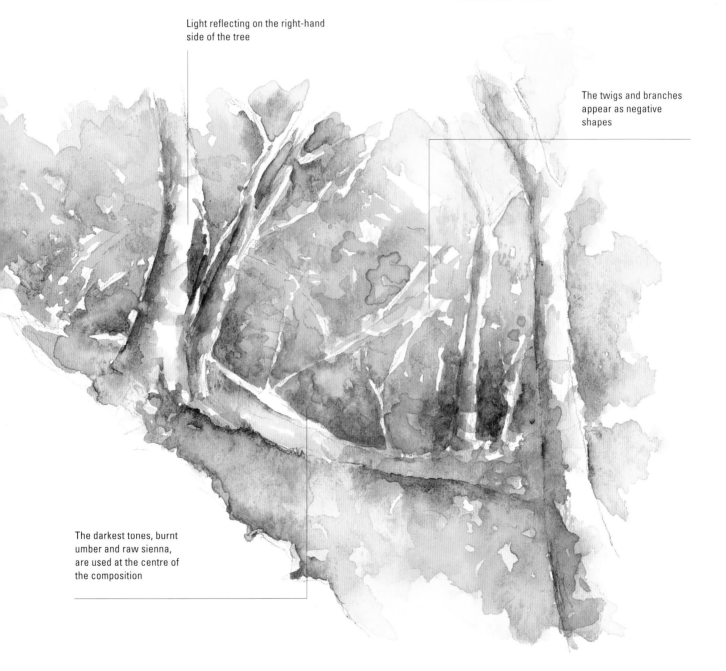

I used a No. 3 brush to paint this on-site sketch on to dry paper. I completed it quickly in an attempt to capture the light of the day before it began to fade. I used a combination of rich reds and browns to try to match the intensity of nature's own colours.

Light reflecting on the right-hand side of the tree

The twigs and branches appear as negative shapes

The darkest tones, burnt umber and raw sienna, are used at the centre of the composition

Referring to the on-site sketch, I started on the actual painting. I used masking fluid to enhance the contrast between light and dark. Masking fluid is a rubber-based solution which should be applied with old brushes. It is waterproof when painted over and so allows you to apply as many washes to your paper as you need without actually getting any paint on to the areas masked off by the fluid. When the paint has fully dried, the masking fluid can be peeled off, leaving a white (negative) shape surrounded by colours which have run and merged together.

One of the hardest stages of all in the watercolour painting process is knowing when to paint and when not to paint. The decision regarding when to leave an area of paper blank and, indeed, how an unpainted space can best be used within a picture is difficult to make. Sometimes the pure white of watercolour paper can be used to suggest highlights in a landscape or shafts of light among the dense foliage of a forest. (I personally never use white paint, preferring the sharpness and clarity of the white paper.) Similarly, it can be used to give the impression of sharp streaks of frost or highlights on snowclad slopes. Gradually, as you develop your own painting style, you will come to know without thinking when this is an appropriate technique to use.

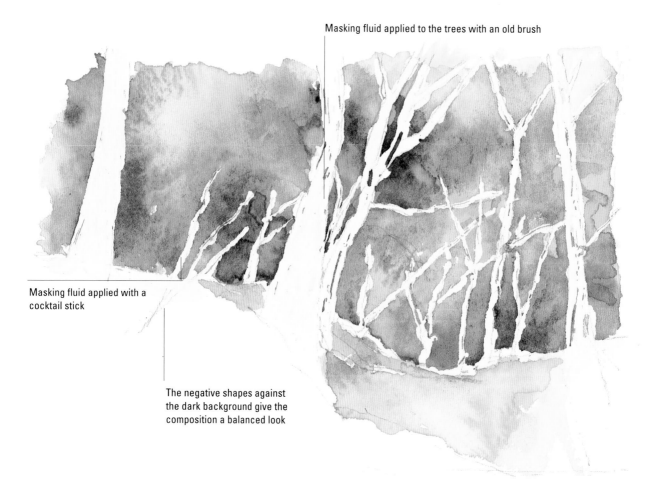

Masking fluid applied to the trees with an old brush

Masking fluid applied with a cocktail stick

The negative shapes against the dark background give the composition a balanced look

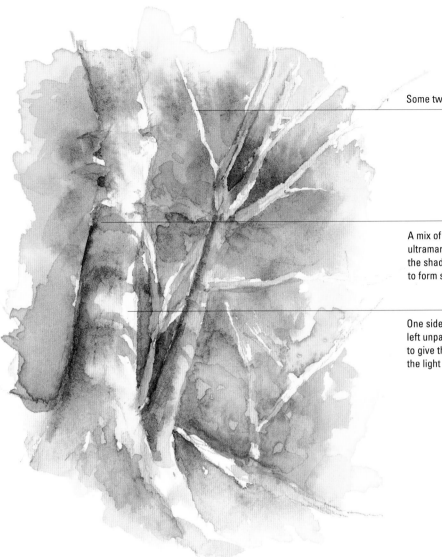

Some twigs remain negative

A mix of burnt umber and ultramarine is applied to the shady side of the tree to form shadows

One side of the trunk is left unpainted in patches to give the impression that the light is falling on to it

Cadmium yellow

Raw sienna

Burnt sienna

Sap green

Burnt umber

The next stage of this picture was to start to paint on to the negative tree shapes created by the masking fluid, although I decided to leave some bare for added impact. I used a No. 3 brush for this. Working on dry paper, I ran a fine dark line along the edge of the shady side of each tree and then drew paint from this across the tree trunk to form the bark. The other edge of the tree was left blank to create the effect of sunlight catching the trunk and some of the branches.

The paint sometimes dries with greater concentration around the edge of the masking fluid so when the fluid is removed, a dark line around the white shape may be evident. For this reason, negative shapes created with masking fluid often have a starker appearance than those created without it. The application of some light colours on selected areas of white will soften the effect if the resulting contrast seems too extreme, but you must make sure that the shape still remains perceptibly lighter than the background or surrounding colours. The combination in this composition of a few sharp white branches and some light-toned boughs was all that was really needed to create the effect of light filtering through into the wood.

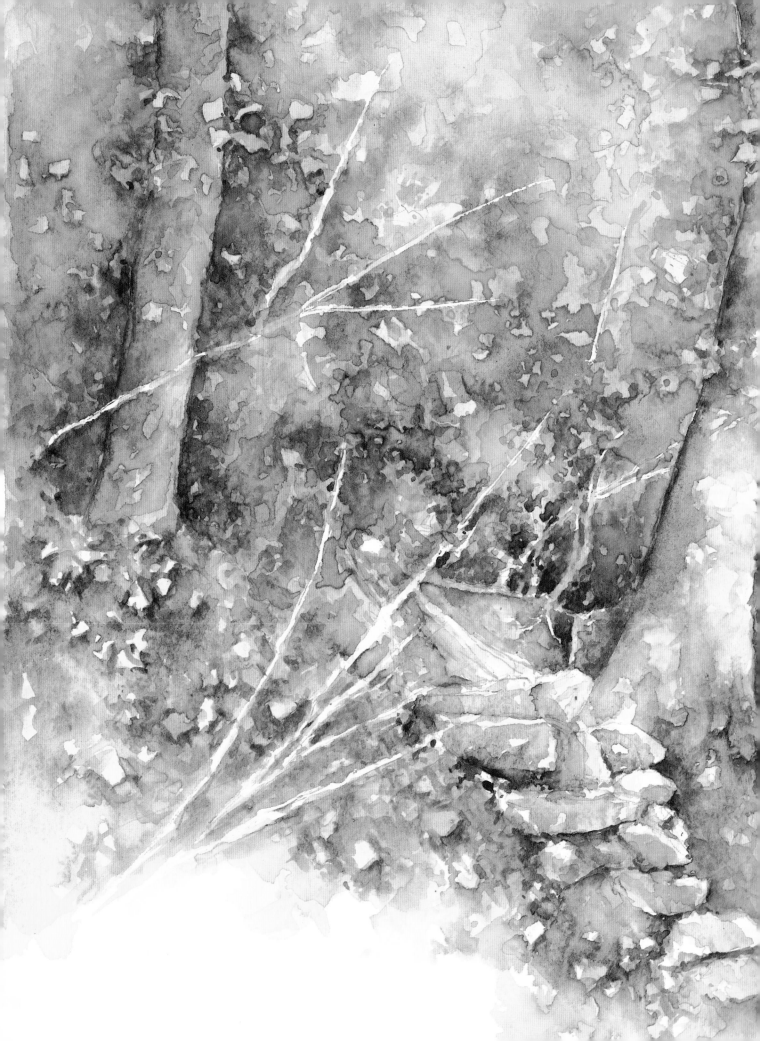

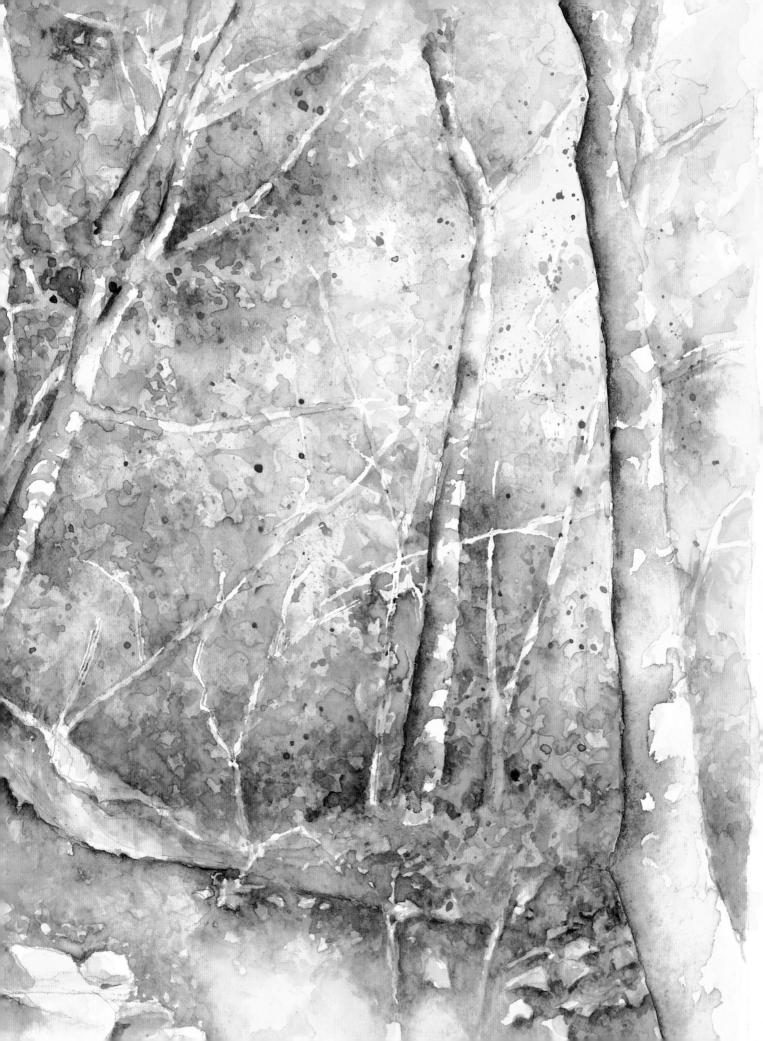

Hints and Tips

- The technique of working on to dry paper using a small brush to apply colour quickly and decisively, rather than building up successive washes, can be useful for capturing the essence of a scene, especially when the effect of light is a major feature.

- A good-quality, strong sheet of paper is needed for paintings that maximize the expressive qualities of watercolour paints. Only the strongest will stand up to the punishment that a succession of watery washes can inflict.

- Masking fluid can be extremely useful if you need to apply a number of washes and then use richer colours for definition, and also if you wish to leave a certain section or shape white.

- Most masking fluids only work well on dry, blank paper. It can be used over a first wash to protect this from subsequent washes but, be warned, it can damage the surface of the paper or discolour the paint on to which it has been applied.

- You can apply masking fluid with any tool you choose but it is best to use sticks or old brushes as the fluid dries so quickly, ruining quality brushes in seconds.

- Never attempt to remove masking fluid until your paper is completely dry. It is removed by peeling and rubbing and this will easily result in you smudging or smearing any damp patches.

- The effect of light catching a surface can be created by leaving the edges of trees and branches unpainted.

- The curve of tree trunks can be enhanced by running a dark line of paint along the shaded edge and pulling it across the width of the trunk, blotting where appropriate. This will give a graduated feel to the shading, making tree trunks and branches appear more rounded.

- Try flicking or spattering some paint on to a nearly finished picture of woodlands to create the effect of loose, almost floating, leaves.

Colour Palette for Project 7

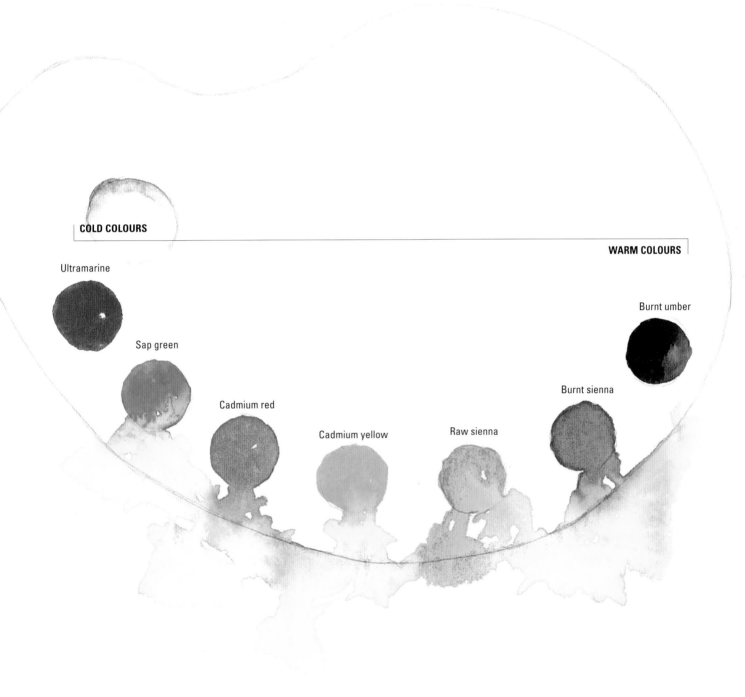

COLD COLOURS

WARM COLOURS

Ultramarine

Burnt umber

Sap green

Cadmium red

Burnt sienna

Cadmium yellow

Raw sienna

Cold Landscapes

Cold colours need not necessarily be associated with dull, grey, lifeless scenes. Landscapes can still sparkle when bathed in a sharp, cool, early-morning light and mountainous landscapes in particular will usually contain a number of cold tints however much heat the day holds.

Blues and greens are the predominant cold colours found in the landscape and are often (though not always) thin colours that dry with a high degree of translucency. They are best used in a build-up of washes or as plain underwashes.

I also included Payne's grey in my list of cold colours. It is a useful colour as it contains pthalocyanine blue, but as it also contains a quantity of black in its composition, it should be used with care. Black tends to flatten a scene and, as it does not occur naturally in the landscape, it has no place in the landscape painter's palette.

Seascapes also feature a high concentration of cold colours – rarely will the rocks of a rugged seashore glow with warmth. Even on the hottest of days, they are perhaps best recorded using the cold blues which tend to be the most appropriate for capturing their overall tone and appearance.

As well as being well suited to glittering, crystal-clear sea- and landscapes, snowy forests, rainswept moors, frosty lakes and streams, cold colours like warm colours can also be used to paint dark and threatening scenes such as a gathering storm. It is also possible to mix cold and warm colours but the proportions of each require special care.

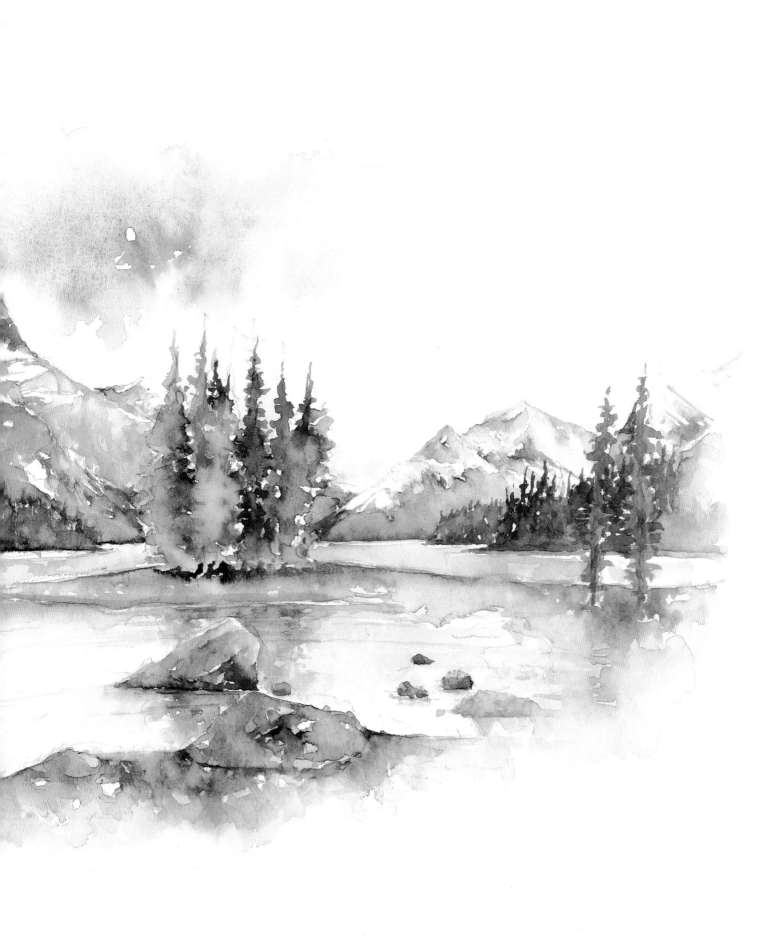

Project 8 **Seashore**

Seascapes and seashores are usually large, open scenes, full of light, space and air. It is particularly important in these scenes that the colour of the sky is reflected in the colours of the sand, rocks and sea. Most seashore scenes will be dominated by blues. Blues from the sky will be reflected in the sea, in the rocks as well as in pebbles, in the shadows and in any distant cliffs surrounding a cove. Other colours will be selected to represent the mineral deposits in the rocks and the type of sand (shingle and gravel are usually a deeper tone than fine soft sand). Rocks can be created as negative images – sketch the outlines and paint in the colours that can be seen behind and underneath so that the rocks stand out pale against a darker background.

As with leaves and foliage, rocks and boulders can be formed as negative shapes by painting around them with dark tones which then appear to push the negative shapes forward.

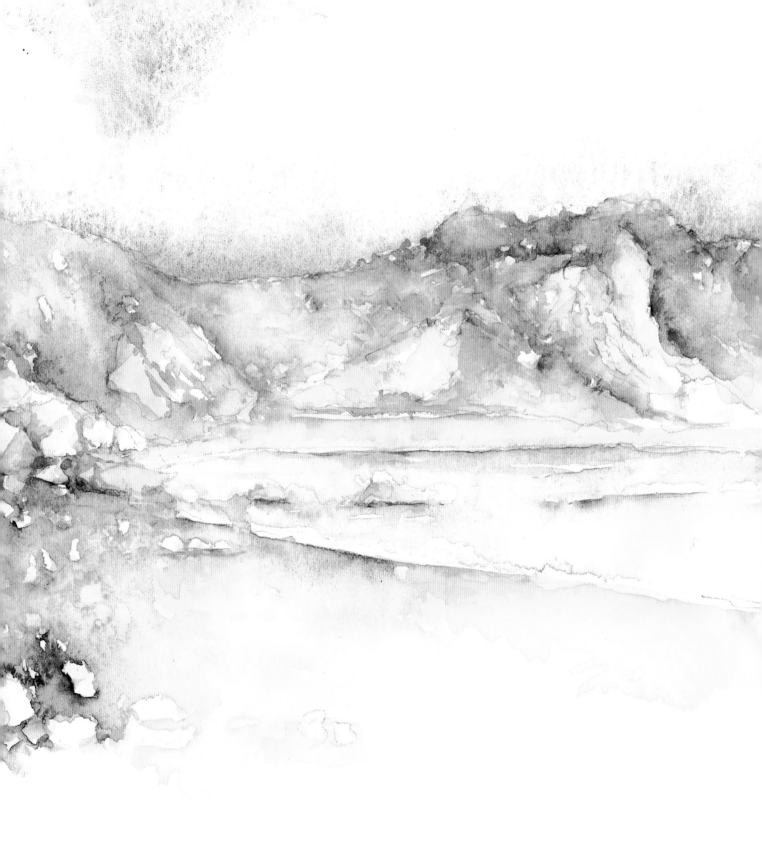

Step-by-Step Rocks and Pebbles

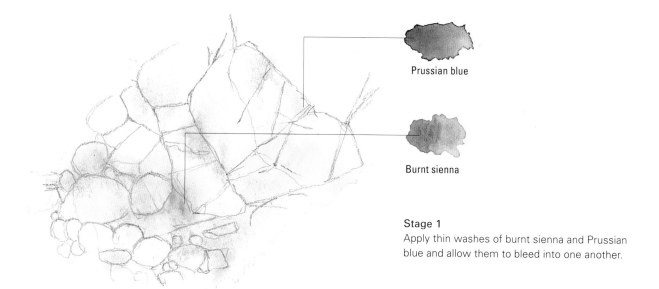

Prussian blue

Burnt sienna

Stage 1
Apply thin washes of burnt sienna and Prussian blue and allow them to bleed into one another.

Having sketched in the basic shapes of the rocks, the first stage of painting is to establish an underwash on which to work. I used burnt sienna and Prussian blue for this and washed each colour separately across the drawing using a No. 9 brush. These first very thin washes were then left to bleed freely into each other.

The next stage is to add some colour to the rocks to build up their shapes. The colour bleeds should be dry before you begin applying more paint over them. The mineral deposits in the rocks gave colour to this section of the beach and were recorded wih a little more accuracy than the initial wash.

Stage 2
Strengthen the colours to establish the rock shapes.

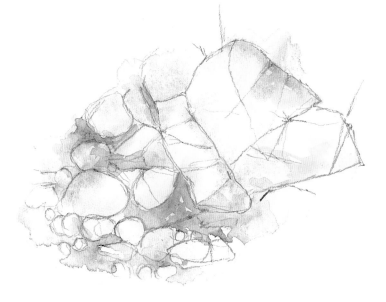

Stage 3
Paint in dark areas and shadows to give greater definition.

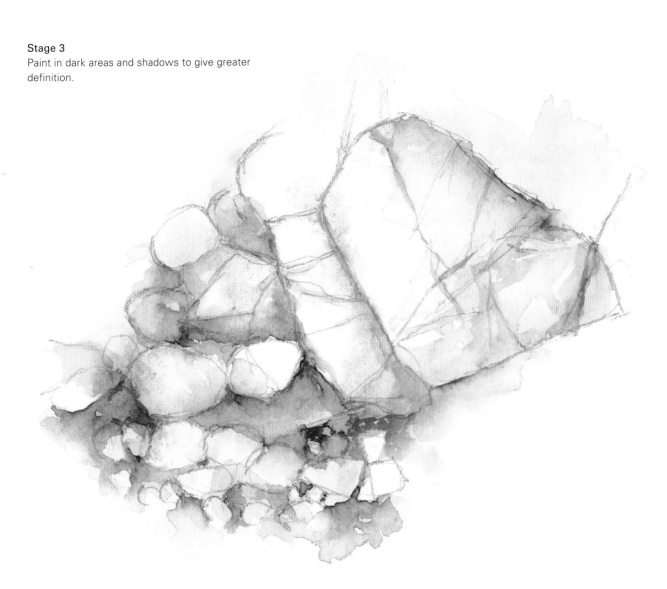

The final stage is to paint in the dark areas with a No. 0 brush. More intense mixtures of the earlier washes were used with the addition of burnt umber and a little Payne's grey giving depth to the shadows, while maintaining the overall coolness of the scene.

The contrast between light and dark is echoed by the contrast between large and small shapes. The finishing touches were provided not by detailed painting but simply by dropping paint on to dry paper to emphasize a few shapes and to form cracks and fissures in the rocks.

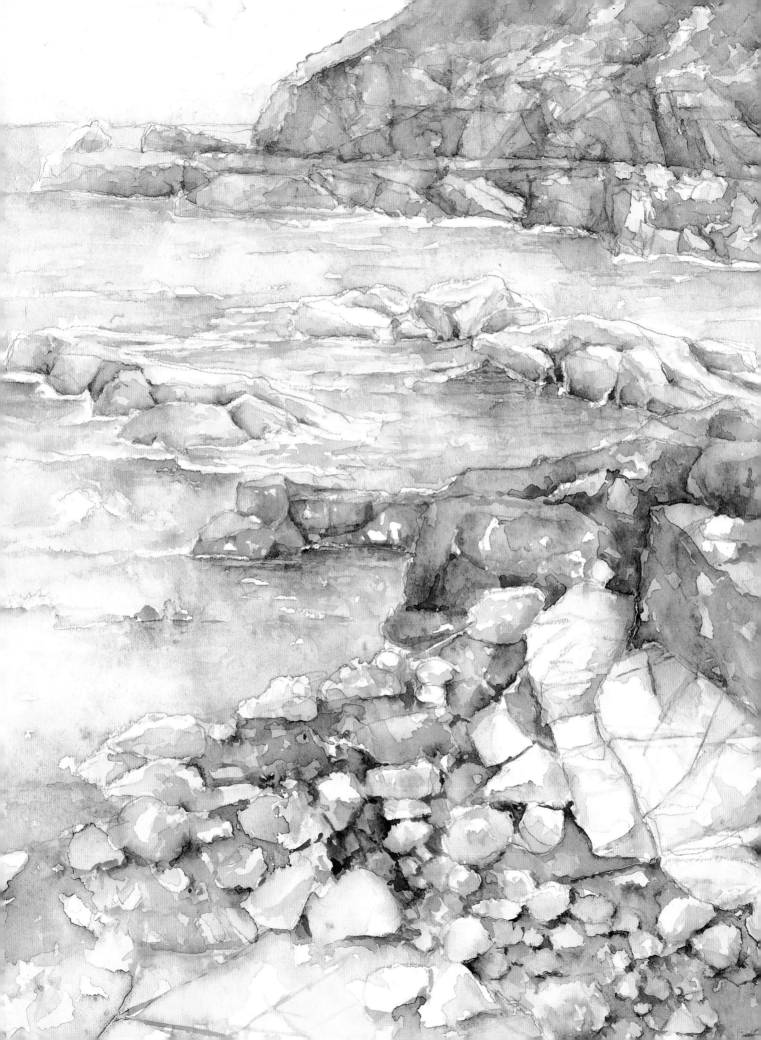

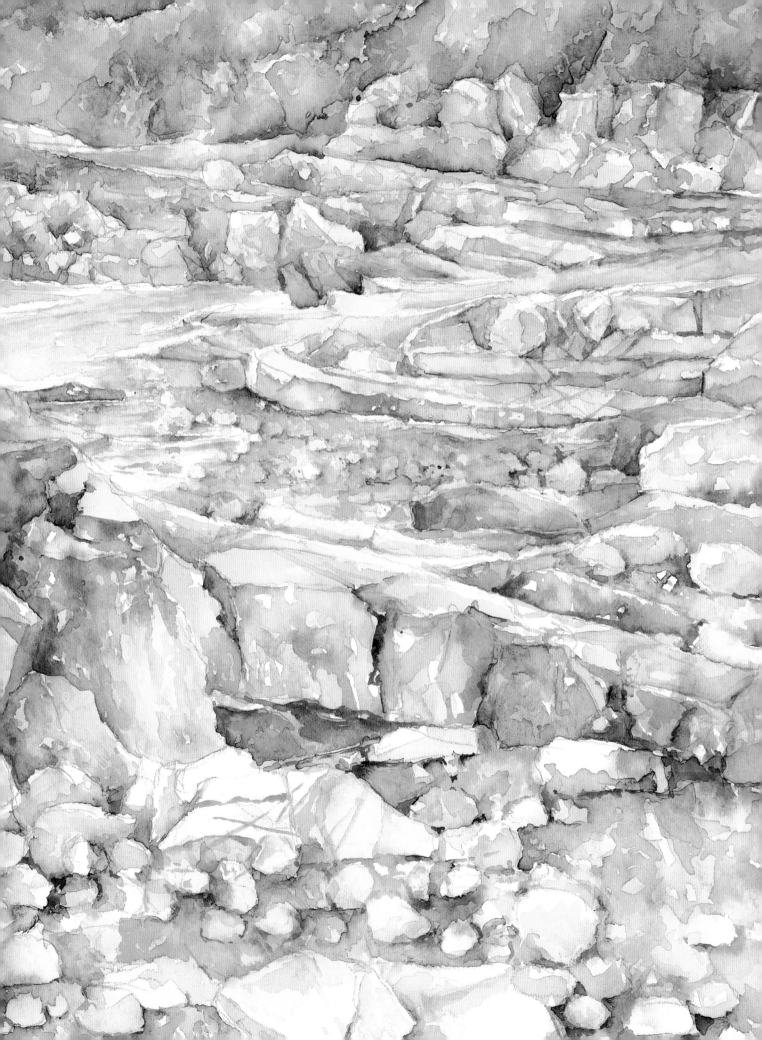

Hints and Tips

- Blues will usually be the most dominant colours in seascapes or seashore scenes. Choose your shade carefully bearing in mind the temperature, colour of the sky and mood of the day.

- Rocks and pebbles are very similar to leaves and foliage in that they are often best formed as pale shapes lightly tinged with colour against a darker background.

- Rocks often feature some interesting colours, which are the result of centuries of natural chemical reactions. Reds and ochres are often found among the sandy greys and bleached whites of seashore boulders.

- Payne's grey can be useful when painting boulders and rocks, but use it sparingly because it contains black which can deaden any sparkle created by blue paints.

- Contrasts of light and dark serve to emphasize the natural chaos of large boulders and small pebbles found on beaches.

- Waves lapping on to beaches or around rocks are best painted using one of the techniques described in project five, i.e. leave a narrow gap of pure white paper along the line of the water's edge to give the impression of a little foam or simply a visual break between what will probably be two quite similar tones.

- Painting seascapes is a subject worthy of a book of its own. But one important aspect to note here is that the colours of the sky may well be darker or lighter than the horizon. It is usually possible to see further out over water than over land and the colours in the furthest distance may well be slightly different from what you expect. As always, study your scene carefully to establish the range of colours stretching out across the sky.

- When you feel that it is appropriate to introduce an aspect of fine detail into your foreground, ensure that the paper that you are working on to is dry. It is easier to control exactly where your paint goes if you do not have a damp surface into which the paint bleeds. Wet on to dry allows you to control the paint.

- Use all three brushes for this type of scene – a No. 9 for the large washes across the sky area, a No. 3 for the undercoat and a No. 0 for the fine detail.

Colour Palette for Project 8

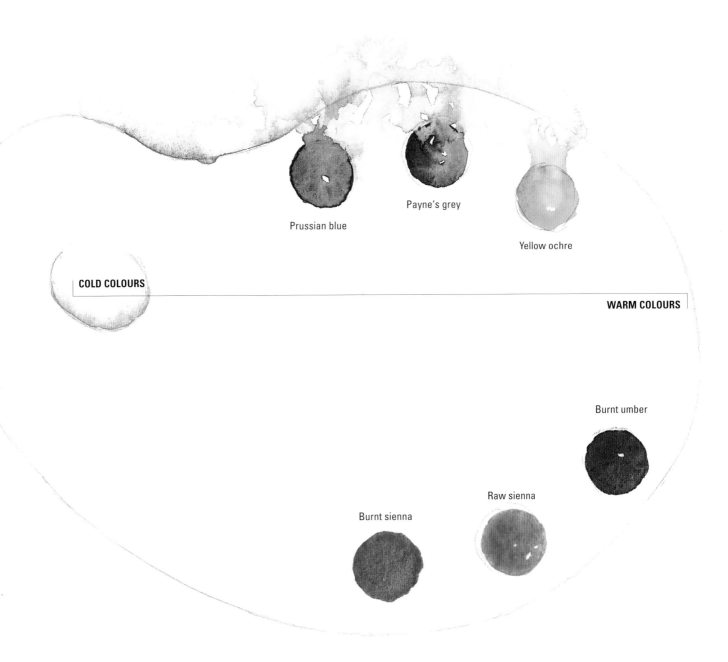

Prussian blue

Payne's grey

Yellow ochre

COLD COLOURS

WARM COLOURS

Burnt umber

Raw sienna

Burnt sienna

Project 9 **Frosty Morning**

I sketched the scene shown opposite
quickly as it was a cold, finger-numbing
morning. I did not venture out early
enough to witness the landscape covered
in the crisp white hoar frost left by the
freezing night. By the time I arrived,
much of the frost covering the ground

had begun to melt away, only lingering on
a few spiky grasses and patches of ground
and foliage that lay within the shaded
confines of the nearby bushes. I recorded
these shapes (shown below) using the
technique of scratching through layers of
paint as described in Project 2, page 52.

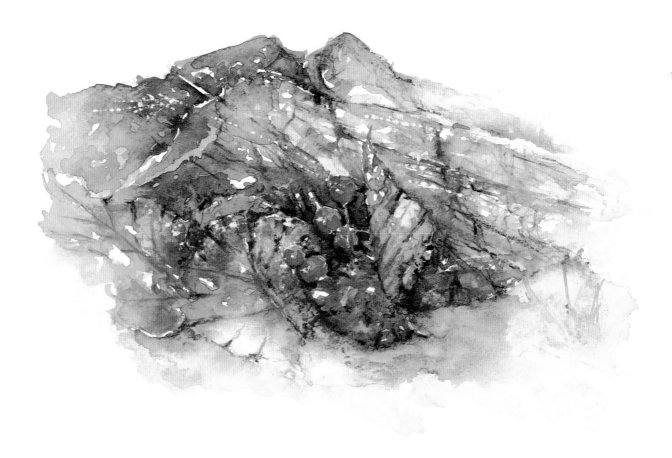

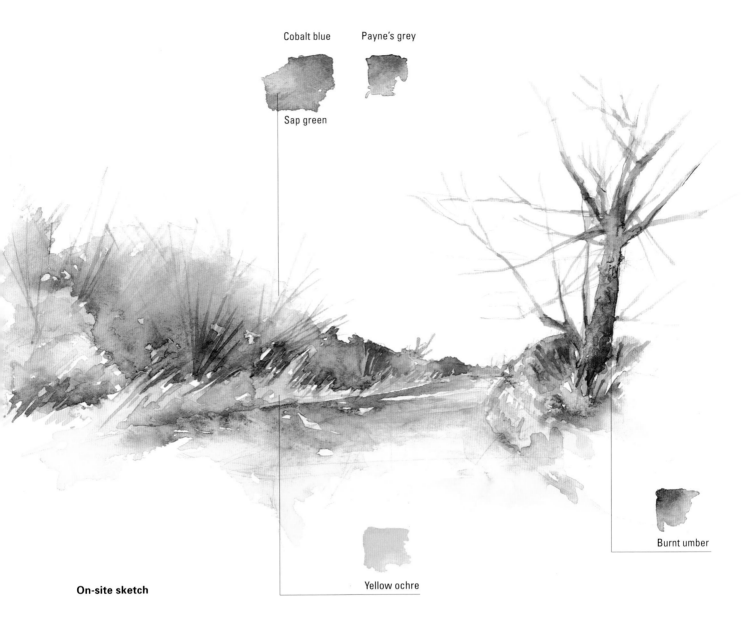

Cobalt blue

Payne's grey

Sap green

Burnt umber

Yellow ochre

On-site sketch

At this time of the year, when the leaves fall from the trees, exposing a complex pattern of bare branches and intertwining twigs, you need a different approach to painting the landscape. It is no more or less challenging; just different. The colours change and seem cooler, reflecting the drop in temperature, but the very nature of winter scenes requires you to use different techniques. During the warmer seasons, the sun encourages growth and landscapes usually appear green and lush.

They are defined by the shapes of trees and bushes in full bloom. During colder months, skeletal tree forms are dotted across scenes and skylines become harsh and sharper. More white will also appear as the frosts and snows arrive, masking shapes and bright colours and creating some fascinating shapes of their own.

At this time of year, when painting in adverse weather conditions, your rough sketching skills will develop rapidly.

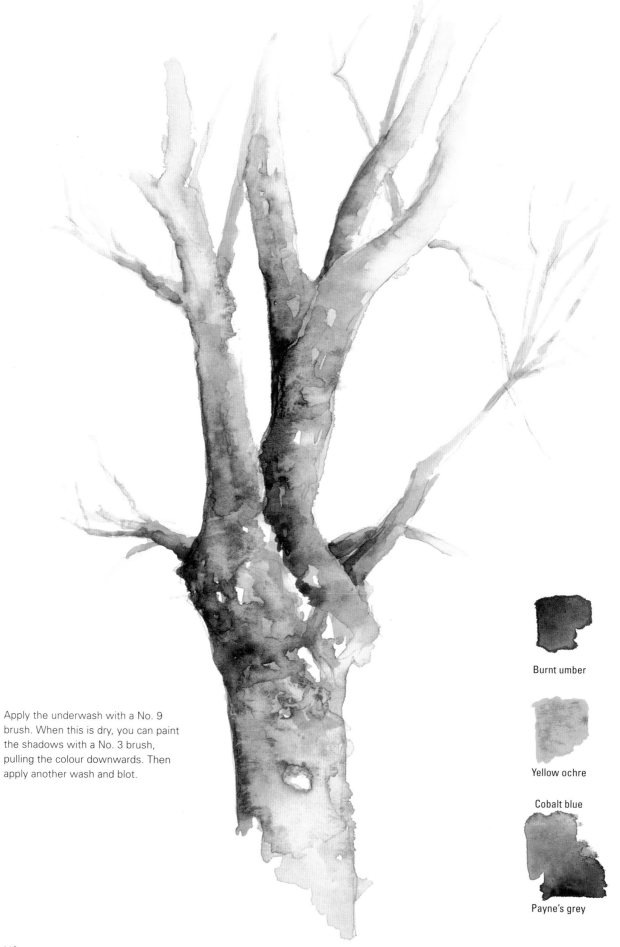

Apply the underwash with a No. 9 brush. When this is dry, you can paint the shadows with a No. 3 brush, pulling the colour downwards. Then apply another wash and blot.

Burnt umber

Yellow ochre

Cobalt blue

Payne's grey

You will need to use a different technique for painting trees when they shed their leaves. You must observe the tree closely if you are to be successful in capturing it in all its complexity. Trees are often gnarled, usually highly textured and never symmetrical. As so much more of the trunk and branches are exposed, trees tend to reflect more of the light of the day, so often require the addition of a greater amount of blue (Prussian blue or, more usually, cobalt blue are suitable).

My technique for painting bare trees involves as much bleeding and blotting as possible in order to achieve the desired effect of textured bark.

After you have sketched in the outline and established a rough idea of the shapes and patterns of the most important boughs and branches, apply the first watercolour wash, aiming for as close as possible a match with the colour of the particular trees. A mix of burnt umber and cobalt blue and sometimes an additional colour usually makes an effective first wash.

Remember that it is neither desirable nor feasible to attempt to paint every branch as this would give the impression of an over-worked picture, compromising the free and fluid style to which watercolour paints are so well suited.

It is usually quite easy to establish the dark shaded side of the tree trunk and, having done so, load your paintbrush with the dark paint, apply it to the paper and pull it downwards along the outer line of the trunk. Before this line of paint has dried, it is helpful to drop on a watery mixture of yellow ochre and burnt umber which bleeds freely. It is then possible to blot out any runs which do not seem quite right, creating a rough texture on the tree trunk.

The branches are then painted selectively using a No. 0 brush and watery paint, tapering them to a fine point towards the ends so as not to make them look too clumsy. There is no need to paint all the branches as a few pencil lines across a cold, grey-blue sky can often look quite effective – especially those on the horizon.

Objects such as pine cones are easily found in woodlands and they make ideal subjects for colour studies.

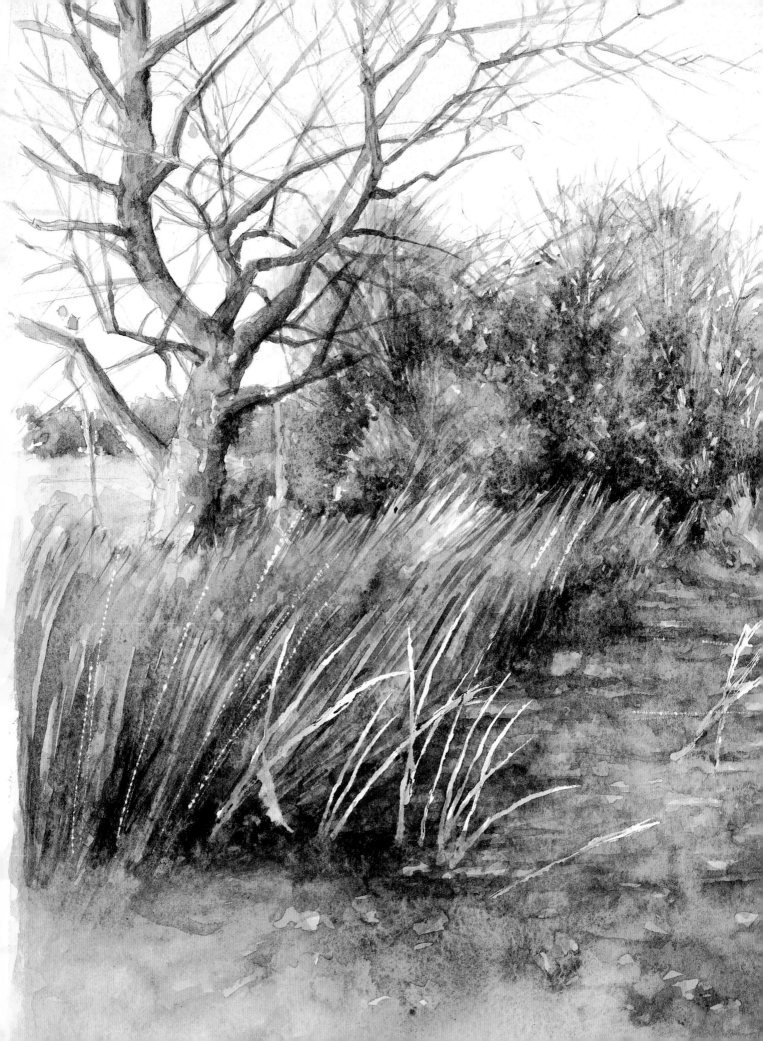

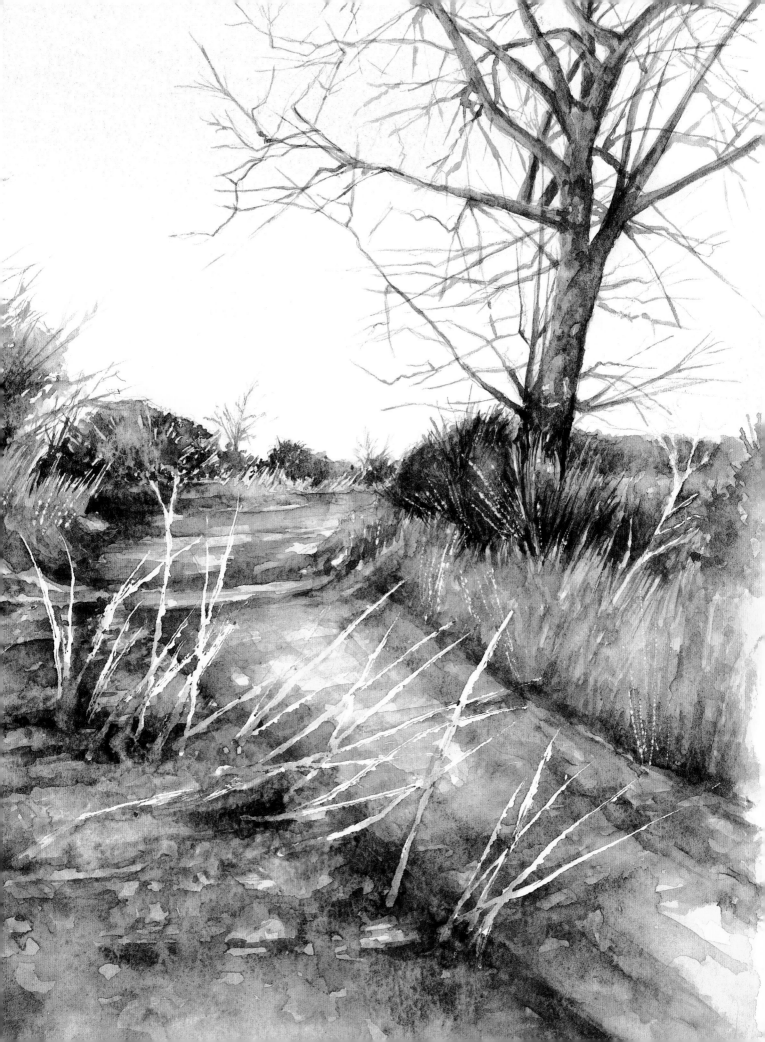

Hints and Tips

- Artists traditionally avoid putting the main feature of the scene right in the middle. It is usually painted slightly off-centre.

- The whole appearance of the landscape changes when trees lose their leaves and new areas and subjects of interest are revealed to the painter – the skeletal shapes and patterns formed by leafless trees for example.

- Do not paint branches and twigs too heavily. They usually become thinner at the very end and are best painted with a fine brush which can be pulled up to a very thin point.

- Winding roads or country paths are frequently featured in paintings; they lead the eye from the foreground right through to the background. They also provide good exercises in tonal painting as the colour of the path will gradually become lighter and it will become less detailed as it moves towards the horizon.

- Trees can be made to look three-dimensional by the skilful application of paint to create patches of light and shade. This can be achieved by pulling a brush loaded with paint along the darker side of the trunk and, before the paint has fully dried, dripping a watery wash on to it. The two coats of paint will bleed and the light side of the tree can then be selectively blotted.

- It is worthwhile studying the points at which branches join tree trunks as there will often be some markings here which can be emphasized with pencil lines and slightly darker shading.

- Branches and twigs that are touched by frost or are stripped bare of their bark can be created by scratching the surface of the painted paper with a very sharp point – but this must only be done when the paper is completely dry.

- Weak sunlight produces weak shadows. A pale pastel sky will produce soft fluid shadows. It is important to remember that whatever the lighting conditions, shadows always exist.

- Use the colour selected for the sky as a base colour for the shadows. A cold blue sky will produce cold blue shadows just as a cold pink sky will produce, as far as the artist is concerned, shadows tinged with pink.

Colour Palette for Project 9

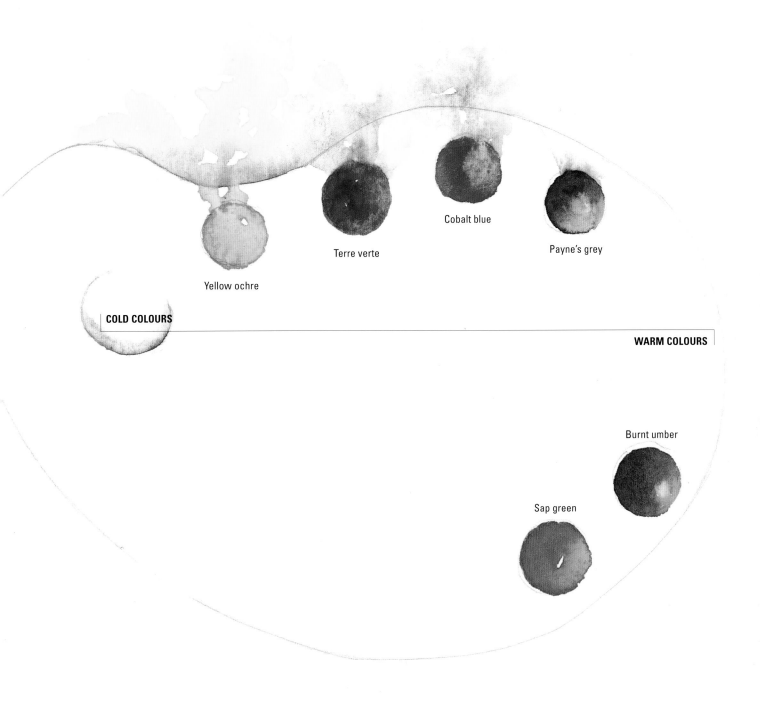

Yellow ochre

Terre verte

Cobalt blue

Payne's grey

COLD COLOURS

WARM COLOURS

Burnt umber

Sap green

Project 10 **Mountain Storm**

Discovering challenging scenes to paint can be very rewarding. This mountain storm scene was particularly exciting as it broke one of the few fundamental rules of most landscape paintings, which is that the foreground should be darker than the background. Unusually in this case, the foreground was actually lighter than the background, with intense strong colours all occurring on the horizon.

Both the sky and the hills were a dark inky colour, creating a scene of visual tension with the threatening stormy background really pushing the stone cairn forward to the front of the composition.

The other aspect of interest in this scene is the contrast between the techniques used to paint the background and the foreground. The storm clouds and hillside in the background were painted with a large (No. 9) brush and were given a very loose and watery treatment. The cairn in the foreground, however, was created with greater accuracy and more attention to detail, each shape and contour being defined with a small (No. 0) only slightly dampened brush. It was important that the brush strokes used in the background and those that appeared in the foreground were not too exaggerated as this would have fragmented the painting.

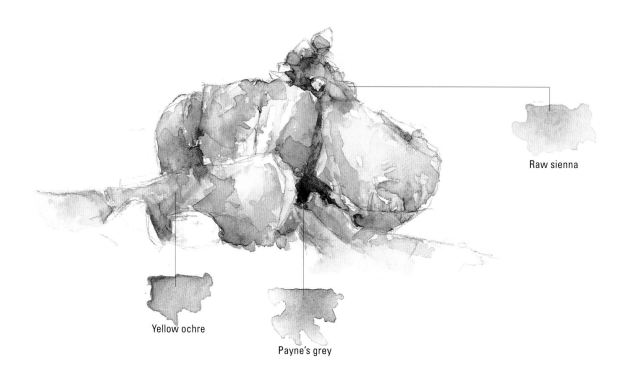

Raw sienna

Yellow ochre

Payne's grey

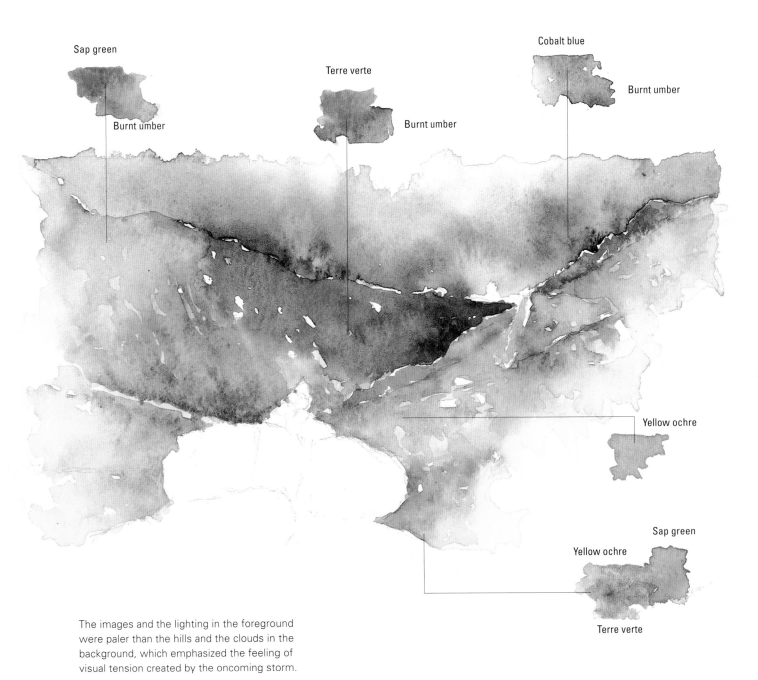

Sap green

Burnt umber

Terre verte

Burnt umber

Cobalt blue

Burnt umber

Yellow ochre

Sap green

Yellow ochre

Terre verte

The images and the lighting in the foreground were paler than the hills and the clouds in the background, which emphasized the feeling of visual tension created by the oncoming storm.

The build-up of tones in the background required the application of several cold colours to create the atmosphere and strength of colour that a gathering storm can bring to a landscape. These paints, which included sap green, burnt umber, terre verte and cobalt blue were washed on to the paper freely and, unusually, were pulled upwards towards the skyline rather than downwards towards the foreground. This resulted in a build-up of paint along the top of the hill, where an accumulation of pigment settled on the textured paper, hence the intensity of colour.

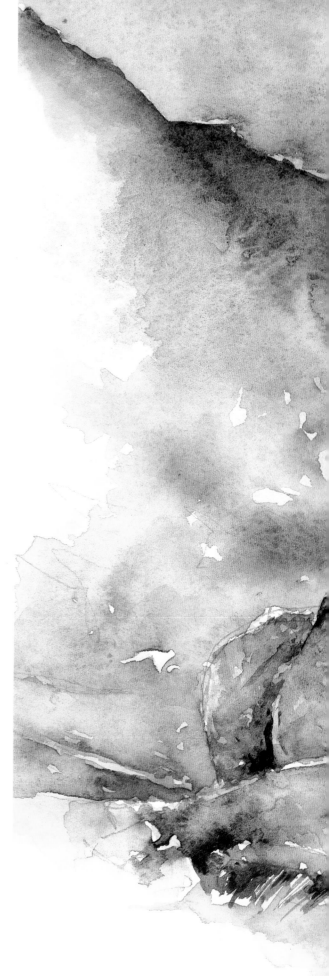

The misty effect along the edge of the hill in the background was achieved simply by allowing a drop or two of water to fall from a brush on to the appropriate spot. This spread, diffusing the colours. The central area was then blotted with the edge of a piece of kitchen roll, removing most of the paint, leaving it as a blank area surrounded by soft, diffused paint. This is a useful technique which can be used to create a misty or hazy atmosphere in a variety of landscapes.

When the lighting is strong and dramatic along the horizon and background, it will almost certainly be echoed in the foreground, usually in the form of intense shadows. This was certainly the case in this particular composition. The stone cairn in the foreground needed very little painting because the dark background almost turned it into a negative shape. I applied a wash of medium strength composed of yellow ochre, Payne's grey and raw sienna to the rocks while a darker mix of Payne's grey and raw sienna was applied in between and underneath them with a No. 0 brush to form fissures, cracks and shadows. This was applied when the first wash of colour on the rocks had dried so the lines would not bleed.

The reality of this painting is that it was completed in two parts – the background on-site and the foreground in the studio. Capturing the atmosphere of this scene in the time I had before the deluge was a challenge and this is reflected in the brush strokes, which have a sense of immediacy and urgency. Having taken sufficient visual notes, I was able to retreat with enough information to enable me to continue working in a much calmer environment.

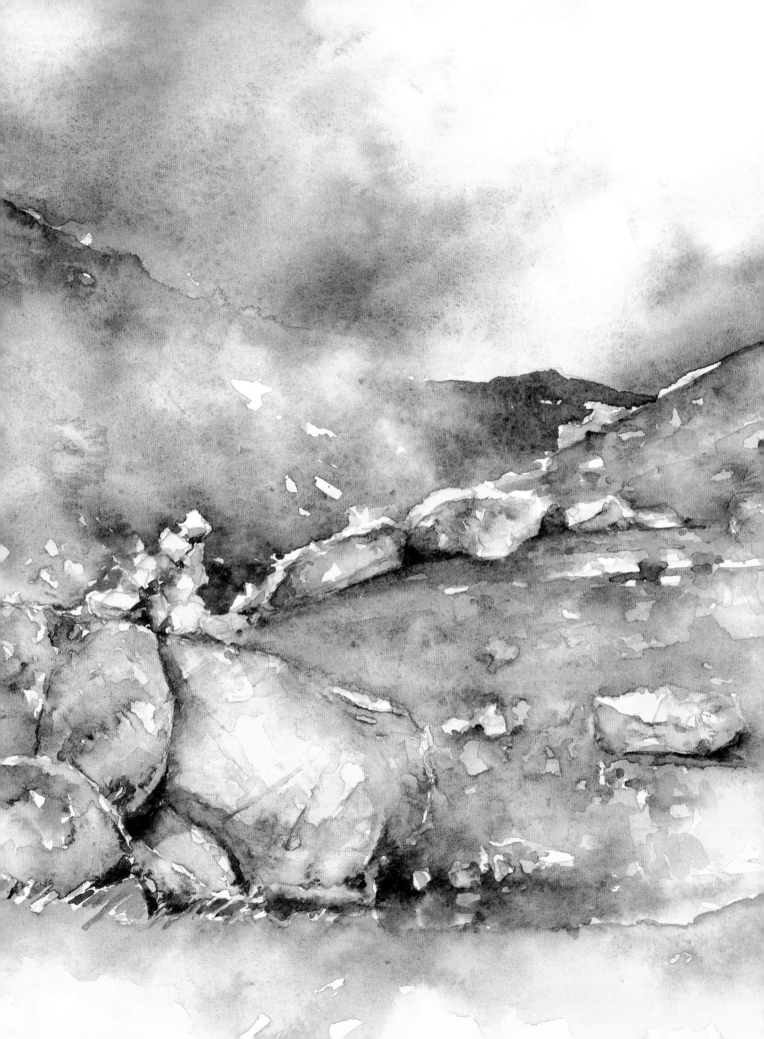

Hints and Tips

- Not all paintings need to be completed in one sitting. You can always come back to a piece of work. Unlike oil paints, the nature of the colours will not change over a long period of time.

- If you are going to paint part of a scene on-site and then take your work away to complete at a later date or in a more comfortable environment, you must make sure that you have the necessary visual information recorded in your sketchbook as memories can play tricks.

- Sometimes the unusual, such as a darker background than foreground, can make a dramatic and effective subject for or feature of a painting, so always be on the lookout for interesting lighting effects.

- Mix your colours for shadows carefully – remember that it is not just a case of applying black paint as this will simply deaden your landscape rather than provide a contrast between light and dark.

- The style of your brush strokes can contribute positively to the overall feel of your picture. Large vigorous brush strokes will usually impart a sense of tension and urgency, while smooth gentle brush strokes on the other hand can give a feeling of calm and tranquillity.

- You can combine different styles of painting in any one scene. There is often room for large expressive washes in the background and more delicate accurate brush work in the foreground. But be warned; this very rarely works the other way around.

- If the main focus of your picture is to be an intense area of sky, then it can be useful to pull the paint towards this point. The paint will accumulate there and will dry with greater strength.

- Always ensure that the strength of the light in the background is balanced by the light in the foreground of your picture.

- Misty patches along mountain ridges can be created by dropping clear water on to a chosen section. This will diffuse the paint and the centre of the area can then be blotted, leaving the outside edges to dry naturally.

Colour Palette for Project 10

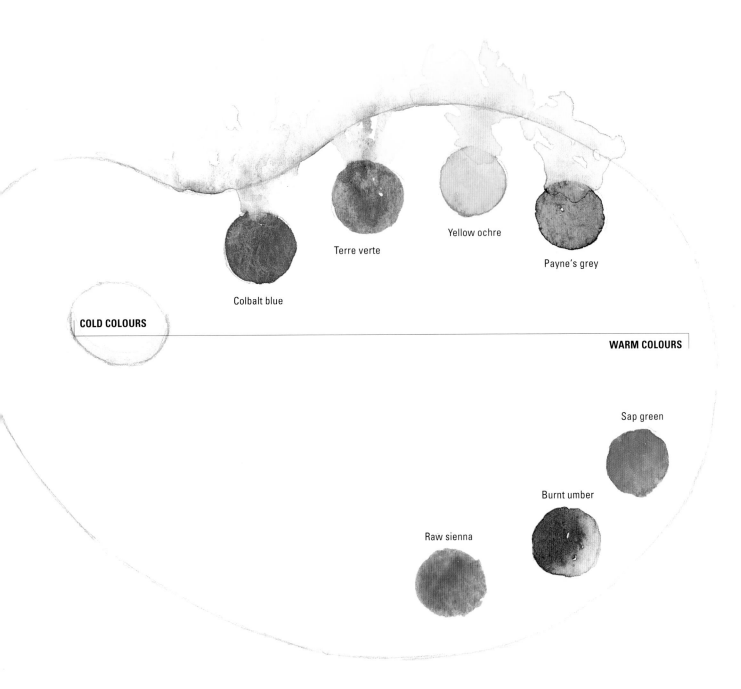

Terre verte

Yellow ochre

Payne's grey

Colbalt blue

COLD COLOURS

WARM COLOURS

Sap green

Burnt umber

Raw sienna

Final Thoughts

I have travelled widely as an artist and consider myself privileged to have witnessed the Arctic sky aglow with the rich, fiery reds of sunrise. I have witnessed thunderstorms that have turned the sky ink-black in Colorado, felt the frozen icy breath of the sharp Alpine air and sweltered under the oppressive heat of the Mediterranean midday sun, and have tried to respond to all these places as a painter. I hope that I have learned some humility in the grip of the awesome power of nature.

In spite of having seen some of these magnificently wild scenes, however, one thing I have learned is that you do not need to travel to the far corners of the globe to find beauty and inspiration in the landscape. The chances are that you will discover scenes worthy of recording in watercolour anywhere you go – very often not far from your own home. The beauty of a landscape can be as much in your hands as it is in the natural forces that created the scene and as a painter you have the ability to capture it.

Enjoy your painting!

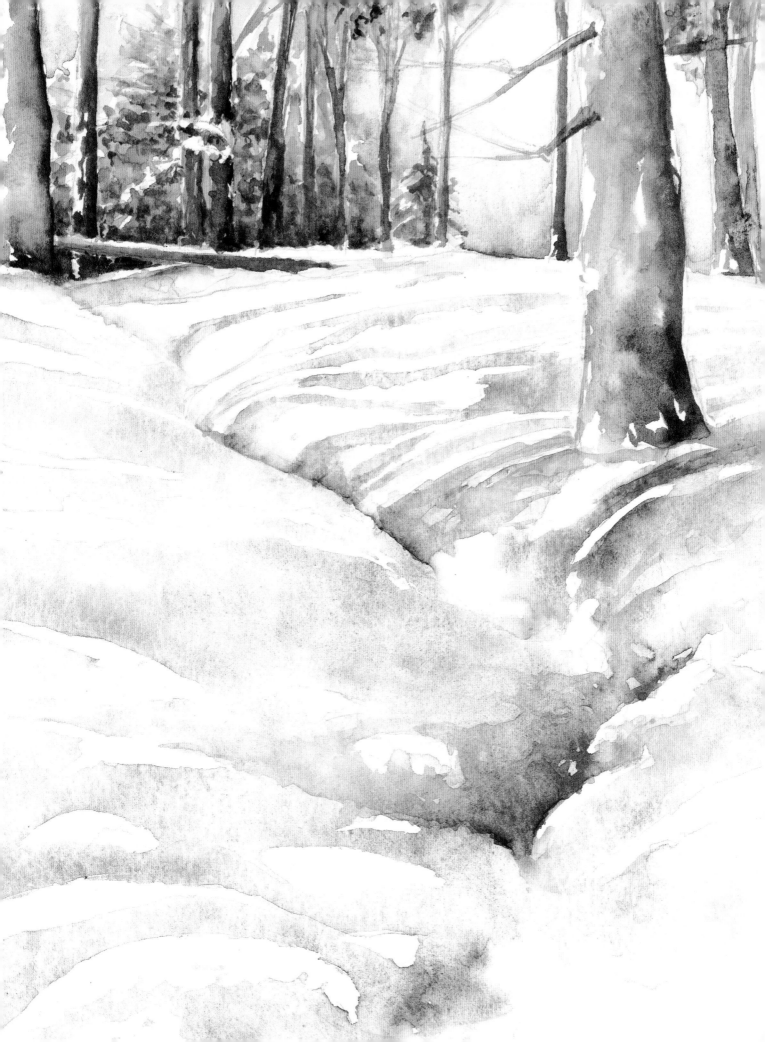

Useful Addresses

Alexander's Art Shop
58 South Clerk Street
Edinburgh EH8 9PS

Artworks
28 Spruce Drive
Paddock Wood
Lightwater
Surrey GU18 5YX

Broad Canvas
20 Broad Street
Oxford
Oxfordshire OX1 3AS

Caran d'Ache
Jakar International Ltd
Hillside House
2-6 Friern Park
London N12 9BX

CJ Graphic Supplies Ltd
32 Bond Street
Brighton
Sussex BN1 1RQ

Colemans
84 High Street
Huntingdon
Cambridgeshire PE18 6DP

Complete Artist
102 Crane Street
Salisbury
Wiltshire SP1 2QD

Daler Rowney
PO Box 10
Bracknell
Berkshire RG12 8ST

The EDCO Shop
47-49 Queen Street
Belfast BT1 6HP

Everyman
13 Cannon Street
Birmingham G2 5EN

Forget-Me-Not
70 Upper James St
Newport
Isle of Wight PO30 1LQ

Gemini Craft Supplies
14 Shakespeare Street
Newcastle Upon Tyne
Tyne & Wear NE1 6AQ

Hearn & Scott
10 Bridge Street
Andover
Hampshire SP10 1BH

Inkspot
1-2 Upper Clifton Street
Cardiff
South Glamorgan CF2 3JB

James Dinsdale Ltd
22-24 King Charles Street
Leeds
Yorkshire LS1 6LT

Mair & Son
46 The Strand
Exmouth
Devon EX8 1AL

Merseyside Framing & Arts Ltd
62-64 Wavertree Road
Liverpool
Merseyside L7 1PH

Millers Ltd
11-15 Clarendon Place
St Georges Cross
Glasgow G20 7PZ

Winsor & Newton
51 Rathbone Place
London W1

USA

Aiko's Art Materials Import
3347 N. Clark Street
Chicago
Illinois 60657

Artist's Connection
20 Constance Ct
PO Box 13007
Hauppauge
New York 11788

Art Express
1561 Broad River Road
Columbia SC 29210

Art Supply Warehouse
360 Main Avenue
Norwalk
Connecticut 06851

Co-Op Artist's Materials
PO Box 53097
Atlanta
Georgia 30355

Napa Valley Art Store
1041 Lincoln Avenue
Napa
California 94558

New York Central Art Supply
62 3rd Avenue
New York 10003

Pentel of America, Ltd
2805 Columbia Street
Torrance
California 9053

Texas Art Supply
2001 Montrose Boulevard
Houston
Texas 77006

Winsor & Newton
PO Box 1396
Piscataway
New Jersey 08855